René VAN WALSEM

ICONOGRAPHY OF
OLD KINGDOM ELITE TOMBS

Analysis & Interpretation,
Theoretical and Methodological Aspects

LEIDEN LEUVEN – DUDLEY, MA
EX ORIENTE LUX 2005 UITGEVERIJ PEETERS

The revision and translation of the original Dutch edition was made possible dur-
ing a sabbatical leave subsidized by the *Netherlands Organisation for Scientific
Research* (NWO: Nederlandse Organisatie voor Wetenschappelijk Onderzoek)

A CIP Record for this book is available from the Library of Congress.

D. 2005/0602/139
PEETERS: ISBN 90-429-1715-6
EX ORIENTE LUX: ISBN-10: 90-726-9015-X
ISBN-13: 9789072690159

PRINTED IN BELGIUM
BY PEETERS / LEUVEN

For
REGINA

TABLE OF CONTENTS

*In certain respects humankind has not changed noticeably in a few
thousands of years. The ability [of man] to express the way he experiences
his world in an artistic fashion, is also of this. Therefore, one
may speak about all kinds of developments in art, but not of progress.*

J.J. Oosten, *Magie en Rede* (*Magic and Reason*), 88 [transl. RvW]

*What art shows is an aspect of the actual reality, stressed and elaborated
in a fictitious reality so that one can see it much more clearly
and is confronted with it much more directly than is the case in daily life.
Every form of art has its own means of expression for this.*

Idem, 72 [id.]

PREFACE & ACKNOWLEDGEMENTS

The present publication is a revised, updated, and extended version of my former *De iconografie van Egyptische elitegraven van het Oude Rijk. De studie van iconografieprogramma's van Egyptische elitegraven van het Oude Rijk. Theoretische en methodologische aspecten* (*ONN* 3, Nijmegen 1994/5).

Although from the very beginning an English version was intended, various priorities obstructed this. However, the main ideas of the Dutch version were presented in a nutshell on the Seventh International Congress of Egyptologists at Cambridge in 1995 and published in Van Walsem, *Iconographic Programmes* (1998).

The core of this essay is a combination of and an elaboration of two former lectures by the author. The first was given at Utrecht on the Netherlands-Flemish Egyptologists' Day in May 1992, presided over by Prof. Dr. D. van der Plas, entitled: "Some un(der)exposed aspects in the study and interpretation of mastaba scenes" ("Enige on(der) belichte aspecten bij de studie en interpretatie van mastabascènes"). The second was an adapted and extended version of the first and was presented during a seminar "Movements and schools in modern religious studies" ("Stromingen en scholen in de moderne godsdienstwetenschap") for research assistants at Ossendrecht, September 1993, presided over by Prof. Dr. K. van der Toorn, entitled: "Religious iconography of Ancient Egypt: methodological and theoretical problems" ("Religieuze iconografie van het Oude Egypte: methodologische en theoretische problematiek"). Next, these presentations were elaborated and incorporated in a series of guest lectures "Egyptian archaeology and art history II" (Egyptische archeologie en kunstgeschiedenis II"), given at the invitation of my deeply regretted colleague, the late Prof. Dr. J. Quaegebeur, at the Catholic University of Louvain (Belgium) during September 1993-January 1994.

What is presented here is a preliminary crystallization of thinking about questions, problems, and aspects that presented themselves during research into the iconography of Old Kingdom elite tombs in the so-called Leiden Mastaba Project (LMP), started in 1980 for teaching advanced students. Since the Egyptian culture has been given shape mainly in connection with the residences of the kings, the elite tombs of the Memphite area only were incorporated into the database. The original paper database consists of individual files on each tomb, giving a plan, wall scheme, a concise description of each subtheme and its accompanying texts (if present). For details on the set-up, the original questions, the intention and some preliminary results on the partially collected material in 1985, see Van Walsem, *Mastaba Project*.

However, since then, the problems and aspects that will be discussed here have come increasingly to the fore, partly due to the publications of Harpur, *Decoration* (1987), Cherpion, *Mastabas* (1989, both primarily descriptive and quantitative) and Kessler's "Bedeutung" (1987, qualitative, i.e. interpretative). Since the Dutch publication of this study, a number of integral monographs on (sub)-themes related to and beyond the questions and problems involved have appeared: Dominicus, *Gesten* (1994), Van Elsbergen, *Fischerei* (1997), Bolshakov, *Double* (1997), Faltings, *Lebensmittelproduktion* (1998), Herb, *Wettkampf* (2001), Fitzenreiter, *Grabdekoration* (2001), and Vasiljevic, *Gefolge* (1995).

The subject matter is very complex and difficult, therefore I name the ideas and thoughts formulated here an "essay". It is an endeavour to order a number of aspects in relation to this subject matter without (too much) inner contradiction. There is no pretence to completeness of the matters treated, either in number or in depth. The only aim is to contribute to becoming conscious of and to develop an understanding of the problems brought up. Because of the many ramifications of certain issues and in order not to interrupt the main text too much, sometimes the notes and glosses are rather extensive and might have been incorporated in the main text. However, a solution satisfactory for all readers for the dilemma: footnote or text is not (always) possible.

Very inspiring for me was my introduction to Wittgenstein's ideas, via J.J. Oosten (*Magic and reason;* only published in Dutch: *Magie en rede*) and W.F. Hermans (*Wittgenstein*, also only in Dutch). The considerable number of mottoes above the various chapters and sections serve to concretize this inspiration. They are certainly not meant to be a pedantic demonstration of the author's reading the *Philosophische Untersuchungen*, nor that he pretends to understand or agree with everything written there. They represent three things. Firstly, the author's pleasure in general in recognizing various philosophical implications and issues which also appear to be fundamental to the particular problems met in the study of Old Kingdom elite tombs, and to discovering a suitable model, viz. that of *language games*, accounting for and explaining most of these problems. Secondly, they are meant to stimulate and focus the reader's attention. Thirdly, they underline the author's conviction of the particular importance of Wittgenstein's later philosophy to the humanities as stressed and demonstrated in several (chapters of) recent publications, e.g. Allen, Turvey, *Wittgenstein* (2001), McGinn, *Wittgenstein* (1997), Sluga, Stern, *Cambridge Companion to Wittgenstein* (1996), Stern, *Wittgenstein* (1995), and Hagberg, *Art as Language* (1995). The mottoes are also given, for the reader's convenience, in the English translation of the *Untersuchungen* by Anscombe.[1]

[1] The, to my knowledge, only publication concerning the (decoration of) Old Kingdom elite tombs that is referring to Wittgenstein is Fitzenreiter's *Grabdekoration*, 69, n. 8 (to *Tractatus logico-philosophicus*, 5.6: "Die Grenzen meiner Sprache, bedeuten die Grenzen meiner Welt").

Here, I thank my colleague Prof. Dr. Dirk van der Plas for inviting me to give two guest lectures on the present subject matter at the Catholic University at Nijmegen (September 1994) and to elaborate an original lecture of 1992 and publish it in the *ONN*-series.

I am very grateful to Prof. Dr. J.F. Borghouts who stimulated me to write an application for the *Netherlands Organisation for Scientific Research* (NWO: Nederlandse Organisatie voor Wetenschappelijk Onderzoek) requesting sabbatical leave for March 17-December 31, 2003 in order to realize this plan. It was accepted, and therefore I owe many thanks not only to NWO but also to my colleagues at the Department of Near Eastern Studies, section Egyptology who took the trouble to find a replacement for me in the person of Dr. B. Hellinckx who took over my teaching duties. I am very much obliged to him as well.

I also wish to express my great thanks and appreciation here for the many deep and enthusiastic discussions with my students about the subject matter of this essay, based among other things on their working papers on studied literature (including the former Dutch edition) and, last but not least, on their reports and even MA theses on detailed studies on various iconographic (sub)-themes.

My friend Jan Zijderveld deserves special mention here. His meticulous and critical reading of the Dutch edition has been of invaluable help to elaborate and/or rephrase for the present edition passages and sentences that were formulated too briefly or too wordy in the former.

Marije Vugts deserves my gratitude for her unselfish effort to create schemes A-C, saving me a lot of trouble and time. She and Hans van den Berg are responsible for the computerization of the database of the material of the Leiden Mastaba Project that is nearing completion thanks to (repeated) subsidies by the *Department of Egyptology*, the Faculty of Arts, the *L(eiden) U(niversity) F(und)*, the *Gratama Foundation* and the *Netherlands Organisation for Scientific Research* (NWO). The English was corrected by Mrs. R.I. Robson MacKillop.

Last but not least, I wish to thank the society "Ex Oriente Lux" and its editor, dr. R.J. Demarée for publishing this volume in the series "Mededelingen en Verhandelingen".

Finally, I must admit that I have experienced in its full extent the truth of Popper's dictum: "Everybody who has done some translating, and who has thought about it, knows that there is no such thing as a grammatically and also almost literal translation. Every good translation is an interpretation of the original text; and I would even go so far as to say that every good translation of a non-trivial text must be a theoretical reconstruction" (quoted by Buchberger, *Transformation*, 11, n. 46). I have tried to the best of my ability to strike a balance between the problems mentioned here. It is to the reader to decide whether I succeeded.

Leiden, August 2005

...works of art, no less than other goods and services
generally, owe their existence to what is now described as 'market forces' –
the interaction of demand and supply.

Gombrich, *Uses of Images*, 6

If half the decoration of Metjen's chapel presents an individual
and his life and constitutes a less grand equivalent of the more
pictorial decoration of the Maidum tombs, what does this imply
about the themes and function of the latter?
This question relates to the essentially unsolved general problem
of the purpose of Old Kingdom tomb decoration.

Baines, *Narrative Biographies*, 34

0. MATERIAL CULTURE AND ART AS TASK

The title of this chapter is an adaptation of a statement by the famous cultural historian Jacob Burckhardt (1818-1897) on his 75th birthday: "Art as task is my legacy".[1] He meant that his successors should study individual works of art as meeting a demand.[2] In that sense one might also use the term *commission*, instead of *task*, with the double meaning of coming from outside (e.g. ordered by a patron) or being set by ourselves.[3]

The visual category of man's sensory interactions with the external world concerns the sub-categories of objects produced and "handled" by nature (e.g. boulders created by earthquakes and moved by rivers) and man-made and man-used objects: *arte*facts, implying a certain skill.[4] A tomb is a concrete, man-made, three-dimensional object and therefore belongs to the world of the latter, i.e. to material culture. This is a tangible result of particular human actions embedded in the overall variety of possible human behaviour.

Therefore, I define – slightly extending the wording in n. 4 – an artefact as: *any concrete, spatially and temporally delimited entity functioning in a man-given context, i.e. distinct from nature itself.*[5]

The fact that, of course, any tangible entity occupies space needs no further comment. However, the aspect of time is a different matter. The period of intentional functioning can best be termed the *use life* of an artefact, which may coincide with its physical existence, but may also be much briefer or intermittent.[6] In short, material culture consists of objects containing more or less

[1] Gombrich, *Uses of images*, 6 gives this as translation of the original German: "Die Kunst nach Aufgaben, das ist mein Vermächtnis".

[2] L.c.

[3] Id.

[4] Cf. *Webster's Dictionary*, I, 124 (sub *artifact*, 2a: a product of artificial character due to extraneous (as human) agency) and 122 (sub *art*, 1b (1): skill in the adaptation of things in the natural world to the uses of human life).

[5] In this definition I combine and extend the two definitions as given, e.g., in Clarke, *Analytical Archaeology*, 489 and Renfrew, Bahn, *Archaeology*, 485. Clarke's "Any object modified by a set of humanly imposed attributes." is too limited. A pottery sherd knapped into a more or less circular shape to serve as a gaming piece on a board game scratched on a floor is obviously an artefact. A naturally shaped pebble taken from its natural context and *used* for the same purpose without any formal modifications is in my opinion at that moment an artefact as well.

For a good understanding: sending a spacecraft to Saturn thereby making the latter function in a human astronomical context does not make the planet an artefact, anymore than is Ayers Rock (or Uluru in the Aboriginal languages of Australia). But certain 'holy' places on the latter, distinct from the rest of the monolith, certainly are 'artefactual' from a religious or cultic point of view. The four portraits of American presidents on Mount Rushmore also make that *part* of the mountain an artefact as well.

[6] See for this: Polz, *Excavation*, 122-123.

encoded 'statements', i.e. man-added and man-extractable or decipherable messages, of potentially various character and levels of meaning.

A special sub-category within material culture is formed by artefacts or objects referred to as *art*. Considering the fact that, as far as I know, not a single book on Egyptian art ignores the representations or iconography in the Old Kingdom tombs, it is obvious that this element is obviously felt to be fundamentally different from the primary *raison d'être* of a tomb, viz. localizing a burial (see below p. 10, 17-19 for a wider discussion).[7]

Since the description and interpretation of representations in both two and three dimensions belongs to iconography/iconology (see below p. 21ff.) as a sub-discipline of the discipline of art history, one needs a definition of "art" and of "art history".

Although the subject of the present essay does not concern the fundamentals of art and I am quite conscious that it is impossible to give an all-encompassing, short formulation,[8] I offer the following definition incorporating the – what I consider universally applicable – essentials for the phenomenon "art":

Art is the term for the individual and/or collective product of human behaviour in which by means of artefacts and/or performances in a relatively creative and original way – beyond the purely functional – a concept (in the widest sense of the word) is skillfully expressed, resulting in an intellectual and emotional interaction between the maker and the observers (including the patron).

A few observations may help to shed more light on this definition.[9] Several aspects formulated here are discussed in Baines' excellent article of note 9 to which the reader is referred in order to avoid a certain repetition of arguments and an over-lengthy discussion extending beyond the framework of the present study.[10]

The first point is that by using the neutral term *artefacts* I deliberately minimize or, at least, lessen the allegedly more or less fundamental difference between the products of craftsmanship and art by artisans, respectively artists.

[7] Wolf's *Kunst*, 199-251 is still the book that devotes the most pages and – for its time – the most penetrating discussion to these scenes.

[8] In this sense I agree with Baines, *Ancient Egyptian Art*, 69, right col., 2nd par.

[9] It is the result of (re)considering and (re)formulating the concept of art for classes on Egyptian art over many years; its present ending was even just formulated while writing this chapter. It may be mainly considered as a kind of personal protest against the – what I consider too facile and thus prone to intellectual laziness – dogmatic statement with which I was confronted in my first year of studying history of art at Leiden University: "It is impossible to give an adequate definition of art".

[10] Baines' resistence, o.c., 68 to Gombrich's opening sentence of his *The Story of Art*: "There really is no such thing as Art. There are only artists" by stating that he, Baines, "would argue that there is 'such a thing as art'" is unfounded. Apparently he has failed to note that Gombrich refines his former statement a few lines below by saying that "Art with a capital A has no existence", thus, Gombrich does acknowledge that 'art' exists.

One can say: "Beautifully made, isn't it?" of even the most ergonomically, i.e. the most functionally, made instrument without any additional "pleasant" and/or "redundant" attributes. Such a reaction is the obvious result of the intellectual (one *understands* that it is primarily a utensil) and emotional (one *feels* a certain satisfaction upon seeing it) interaction between the maker and the observer, the one *who takes notice*. All three notions, taking notice, understanding, and feeling, are covered by the single Greek verb "aisthanomai",[11] from which "aesthetics" is derived. Since the early nineteenth century this term has been increasingly used in art criticism and art history to refer almost solely – as a kind of synonym – to the 'pure beauty' inherent to products of art, culminating in the expression "l'art pour l'art", the main criterion for distinguishing the work of an artist (= art) from that of an artisan (= applied art/craft).[12]

Although beauty[13] is undeniably *an* aspect of art, it may never be used as the *only* decisive criterion for the simple reason that, although not every artefact is necessarily an art product, every art product is necessarily an artefact according to our definition (see p. 1). In other words: *art represents a specific category of artefacts.*

All artefacts are ultimately based on mental images or concepts in the human mind.[14] The realization of such images in any concrete artefact or art product always implies a minimal degree of skill or technique, in short craftsmanship. Since any artefact as such thereby comprises the notions of both "art" and "craft", it is obvious that the difference between art and applied art is only *gradual* and *fluent*, not *absolute* and *sharp*.[15] What, then, makes a 'neutral' artefact into an art product?

Part of the answer is: a certain degree, or a certain concentration and combination of *redundant* attributes beyond the strictly functional. However, no art product is completely without any function. Even the most "useless" piece of art is evidence of the fact it *had* to be made, implying a function, otherwise it would not have existed. As such, it always represents a need or demand for recognition by a 'public', potentially ranging from at least one single other individual to the general mass of people that is public as a qualitative rather than a quantitative entity.[16] Artist/artisan and public meet in the context

[11] Liddell, Scott, *Greek-English Lexicon*, 42

[12] See Honderich, *Philosophy*, 8-16, s.v. "aestheticism", "aesthetic judgment", "aesthetics, history of", "aesthetics, problems of", "aesthetic value", 59-60, s.v. "art", "art criticism" and 80-81, s.v. "beauty"; Osborne, *Art*, 11-12, s.v. "aestheticism", "aesthetics", 60-61, s.v. "applied art", 406-407, s.v. "fine arts".

[13] For the various aspects and problems concerning beauty (e.g. great works of art can be ugly or gruesome), see Honderich, o.c., 80-81, s.v. "beauty".

[14] See Clarke, *Archaeology*, 200, fig. 48.

[15] As is discussed by Janson, *History of Art*, 17.

[16] Cf. o.c., 17; Gombrich, *Uses of images*, 6.

of "what matters" to both parties, which encompasses much more than the mere "function" of an object.

Part of the answer is also: originality or creativity expressed by the combination of the composing attributes of the artefact in the sense of opening up new horizons. However, originality and creativity are not absolute entities either and do not exist in a vacuum. Adding new attributes to any 'tradition' (a feature that is common to both craft and art)[17] or even repudiating tradition must always occur against the background of something already there, making originality and creativity something *relative* by nature. In different products they only exist to a certain *degree.* [18]

Summarizing, it is impossible to distinguish artefacts in general and their sub-category – products of art – in a *fundamentally absolute* way.[19] Yet there is art. Possibly one of the best criteria to discern the dividing line between art objects and mere artefacts is the *complexity* of the stock of ideas and emotions – irrelevant to the *practical* use – that are encapsulated in the former. Although, as said before, both artist/artisan and public have something in common "that matters", a (very) high complexity of ideas and emotions is the core of "what matters" in works of art.

The fact that the aspects discussed are not static leads us to *art history*. This can best be conceived of as the study of the temporal and cultural functioning of the various aspects in the proposed definition of art. Although art history is a discipline in the humanities, one should realize that to achieve a full picture of "reality" the humanities and exact sciences are complementary by the use of statistics, to mention just one tool of research.[20]

Irrespective of whether the iconography of Old Kingdom tombs has to be considered as the work of artisans or artists,[21] it represents various "tasks". Its patron set himself the task of decorating the walls of his tomb and thereafter he made it a task for those who executed it to realize this. It is the Egyptologist's task to analyse and interpret it scientifically, using a sound methodology based on a well-thought-out theory. The author has set himself the task of making a contribution to this aim, which brings us neatly back to Burckhardt's statement.

[17] O.c., 16.

[18] As discussed with various examples by Janson, o.c., 14-16, e.g. the composition of Manet's "Luncheon on the grass" can be traced via Raphael to the classical example of river gods, yet it remains a highly original and creative work.

[19] This is reflected in Vandersleyen, *Ägypten*, pls. 343-401 where several sub-categories of applied arts of various periods (pottery, furniture, glass and the like) are included among "real" art, while Wolf, *Kunst*, includes only prehistoric pottery (figs. 1-6) and a New Kingdom mirror and some unguent vessels (figs. 410-418), because human figures are involved.

[20] See on this complementarity Panofsky, *History of Art*, especially, 47-49; Clarke, *Archaeology*, 486 and Van Walsem, *Djedmonthuiufankh*, 1-3.

[21] Cf. once more Baines, o.c., 68-70.

Man muss schon etwas wissen (oder können), um nach der Benennung fragen zu können. Aber was muss man wissen?

One has to know (or be able to do) something in order to be capable of asking a thing's name. But what does one have to know?

Wittgenstein, Philosophische Untersuchungen, 30

1. QUESTIONS

The title of the present study indubitably delimits the material object of study, that is the representations found in the tombs of the Old Egyptian elite during a specific period. It also delimits the nature of the well-circumscribed aspects that such a study implies, namely the theoretical and methodological parameters. Therefore, the reader will not find an integral description and explanation of a decoration programme that may be found, for instance, in the tomb chapel of Hetepherakhty in the Rijksmuseum van Oudheden (RMO; National Museum of Antiquities) in Leiden, or in that of Neferirtenef's in the Museum van Schone Kunsten (Museum of Fine Arts) in Brussels.[1]

On the contrary, the problems here are the central questions met in devising a scientific approach for describing and interpreting the representations left by the ancient Egyptians. Having taken a closer look, and probably reluctantly, the (enthusiastic) researcher has to admit that these problems appear almost overwhelming in their complexity. The author, at least, was unconscious of what he had embarked on while preparing a seminar for advanced (MA) students on the decoration of the chapel in the RMO.

Everyone who enters such a richly decorated room and allows what they see to sink in will be overwhelmed by questions. The explicit formulation of questions such as: "What makes a tomb an elite tomb? What does one find in it? What does it reflect?" is usually not a problem. However, the method ("How should the present artefact be analysed in a well-founded and reliable way?"), as well as its theoretical foundation ("What starting-points or premises were employed?"), which should produce the desired knowledge and on which a possible answer should be based, is seldom made explicit by the person who gives the answer. Nevertheless, this is of vital importance to the collecting of new and/or the underpinning of already existing (supposed) knowledge. We are in deep, complex waters here. For nor any question or indeed its answer operate in a cognitive vacuum, but is embedded in its cultural background, which is pre-existent.[2]

[1] Hetepherakhty's tomb chapel has been (completely or partly) published in Holwerda, *Beschreibung, I*; Mohr, *Hetep-her-akhty*; Klasens, *Kunst*, 20-21, figs. 14-20; Schneider, Raven, *Egyptische Oudheid*, 49-53. Neferirtenef's was completely published in Van de Walle, *Neferirtenef*.
[2] Cf. Shanks, Tilly, *Re-constructing Archaeology*, especially ch. 1.

*Die für uns wichtigsten Aspekte der Dinge sind durch ihre Einfachheit
und Alltäglichkeit verborgen. (Man kann es nicht bemerken, – weil man es
immer vor Augen hat.) Die eigentlichen Grundlagen seiner Forschung fallen
dem Menschen gar nicht auf...*

*The aspects of things that are most important for us are hidden because of
their simplicity and familiarity. (One is unable to notice something – because it
is always before one's eyes). The real foundations of his enquiry do not strike
a man at all...*

Wittgenstein, Philosophische Untersuchungen, 129

*...Um klarer zu sehen, müssen wir hier, wie in unzähligen ähnlichen Fällen,
die Einzelheiten der Vorgänge ins Auge fassen; was vorgeht aus der
Nähe betrachten.*

*...In order to see more clearly, here as in countless similar cases, we must
focus on the details of what goes on; must look at them from close to.*

Idem, 51

2. COMPLEXITY

The first complication begins with the person who is entering the tomb chapel: whether he be a layman or a professional Egyptologist. Both ask questions but these will coincide only partly. Therefore, a layman, certainly in the first instance, will not be interested in the final questions on the previous page. However, an important point is that both silently assume that the Egyptologist is the more capable of answering questions, simply because of his professional knowledge. It means that it may be expected that he is able to answer not only the questions he asks himself professionally, but also those posed by a layman. Further, one may demand of him, irrespective the origin of the questions, that the answers he gives will be as well founded as is scientifically[1] possible.

Another complication of which one should be conscious is that according to their nature they should be differentiated into quantitative and qualitative ones. Questions of the first order with regard to fig. 1 (p. 18) are, for instance: "How many elite tombs are there? How often does a certain scene occur? and/or Where does it occur (orientation in the tomb: north, east, south, west wall(s), respectively place on the wall: upper, middle, lower part)?" The answers to the last questions (the two levels of "where?") are purely descriptive. However much a numerical answer to the first question, viz. the total number of tombs, may seem purely descriptive, for instance 695,[2] this is not completely correct. Namely, by giving this answer without further explication, one implies that it is already clear what an "elite tomb" is. The answer to this question, has to be qualitative. A qualitative answer may have a descriptive component, to do with the number of rooms and/or square metres and so forth, but it must inexorably contain (an) interpretative component(s), such as which (sub)-themes of decoration occur with or without which texts.

Although a response to the question "What (sub)-themes does one find?" also seems to have a simple descriptive answer, again, the situation is more complex than it may seem to have superficially. Comparing fig. 2 (p. 35), second register from below, to the left of the large figure in the middle with fig. 3 (p. 36), first register from above, to the right of the middle, one will say in the first case that two "hexagonal objects" are depicted, while in the latter case one can speak of a "hexagonal trap-net for birds". The birds clearly present in fig. 3 make this seem a case of a (purely) descriptive answer, but in

[1] That is: applying a thorough, coherent, consistent, systematic and verifiable methodology.

[2] Harpur, *Decoration*, 282. Here it concerns only the *tombs* all over Egypt still recognizable as independent entities. However, if all *fragments* she registered were to have originated from different tombs, the number could be 750 (o.c., 284).

respect of fig. 2 it is partly descriptive, partly interpretative.[3] Now, this is a simple case where the interpretation remains superficial, it primarily concerns a description/interpretation referring to the visual or factual reality. Much more complicated is the matter of whether, and to what extent, the scene might be interpreted as referring to something beyond this reality (see below, p. 33-34; 36-39), that is metaphorical or symbolic.

The conclusion is not only that every "description" that goes beyond the purely formal – i.e. which tells something *of* ("two *hexagonal* objects"), but also *about* ("hexagonal *clap-net*") the shape – is interpretative. It also shows that the word "interpretation" may be slotted hierarchically in various levels, depending on the existential framework to which it is referring. This will be discussed in more detail on p. 25, n. 14, and pp. 33, 36-39.

These complications are expressed to the full light of day in the next (incomplete) series of descriptions or naming of tombs used in Egyptology: 1. pre-historic tomb; 2. *mastaba*(-tomb);[4] 3. rock tomb; 4. elite tomb; 5. pyramid tomb; 6. royal tomb; 7. private tomb; 8. symbolic tomb; 9 family tomb. The only common element in the series is the word "tomb", further qualified by nouns and adjectives. Although the etymology of the word refers to a "tumulus" meaning an artificial hillock or mound over a grave,[5] in modern English it is the most objective[6] term for any arbitrary place where – withdrawn from direct physical contact – the remains of a human being are, should be,[7] or could[8] be permanently laid to rest.

In other words, an artefact is not a tomb until a location, irrespective of its external marking, is in some way associated with a corpse. Therefore, a corpse present materially or immaterially[9] is the only criterion (simultaneously identical to an empirical fact) that makes it possible to form such a series of statements. Although consequently a corpse is the central, necessary fact for

[3] The fact that fig. 2 serves in Davies, *Ptahhetep*, pl. 21 only as a survey plate in which the details mentioned were omitted, while being present in detail in Paget, Pirie, *Ptah-hetep*, pls. 22-23, does not invalidate the complication established. After all, it is highly conceivable that in one tomb the contours of the net are executed in relief, the birds once painted in it now being lost, while in another tomb both were executed in relief and are thus (better) preserved.

[4] Mariette coined the term especially for the Old Kingdom bench-shaped (= Arabic *mastaba*) tomb superstructures, cf. idem, *Mastabas*, 22-23.

[5] Cf. *Webster's Dictionary*, III, 2406, 2462.

[6] One should be aware that terms as "burial", "grave", "pit", "sepulchre", "vault" cannot follow all nine qualifications of the word "tomb", because of subtle shades in meaning originating in the fact that these terms refer to more than the strict definition of "tomb" in the main text. Indeed, all "burials", "graves", "pits", "sepulchres" and "vaults" are (final) "resting-places", but not in reverse.

[7] Think of violation of a tomb.

[8] Think of a symbolic tomb or cenotaph (= Greek, "empty tomb"). For the variety of this kind of tombs, cf. *OEAE*, I, 244-248.

[9] In the case of a cenotaph one can speak of an "immaterial" or "imaginary" presence that is "projected" by the purveyors of culture.

even uttering the word "tomb", it does not occupy at all (nos. 1-3, 5) or only indirectly (nos. 4, 6-9) the centre of the attention of an observer. Pertinently, these two groups themselves are not homogeneous: in no. 1 chronology is central; in 2, 3 and 5 architectonic shape; in 4, 7 and 9 social position; in 6 social, political and/or religious position; and in 8 religious and/or political[10]. Going one step further the matter is even more complicated for two reasons. Firstly, apart from no. 5 that corresponds most closely to an Old Egyptian term,[11] the specifying terms used mainly tell us something about the criteria employed by the *modern (Western) researcher*. Secondly, they are not mutually exclusive: fig. 1, namely, is simultaneously a mastaba, a rock, an elite and a family tomb.[12] If one uses, as is mostly the case, a single term for a tomb, this reveals the apparently most dominant aspect catching the attention and act of speech of the observer, simultaneously excluding and/or leaving other aspects unexposed. This can be attributed to the various "language-games" (see p. 67ff.) [13] used by the researcher at the moment of observation, which are followed by description/interpretation.

However, each of the terms mentioned is itself the result of the application of a set of rules by the researcher on the basis of a specific phrasing of a question which itself implies a pre-existent knowledge – cf. Wittgenstein's dictum above p. 6 – of certain aspects of the phenomenon "death" in its various cultural contexts. One does not (need to) apply the same rules, necessary to the analysis of representations and texts, to identify, or circumscribe an architectonic shape in order to establish whether one is dealing with a private or a royal tomb.[14] The set of rules used, in its own turn, is (partly) activated by one certain category or even several categories of signals and marks that are, as it were, "broadcast" by the object. This means that any artefact[15] is a complex codified sign system that forms an information medium between its maker and the observer.[16] This is in accordance with the idea in cognitive archaeology

[10] Think of the "south tomb" of King Djoser's burial complex at Saqqara (religious and political(?), respectively the cenotaphs of private persons along the processional way of the Osiris temple at Abydos; cf. also n. 6.

[11] Namely *mr*: *WB*, 2, 94,14. The situation with regard to the pyramid is more complex, since it also has a fluctuating, "elite" connotation: in the Old and Middle Kingdoms it was used only for royalty; in the New Kingdom only for the elite, while from the 25th dynasty in Nubia only for royalty again.

[12] See Moussa, Altenmüller, *Nianchchnum*, 22, for the family relations between the two owners.

[13] Cf. for an example p. 83 on the description of Paris.

[14] Only to the *pyramids* in the Old and Middle Kingdom does it apply that the *form* can be used to distinguish absolutely between royal and private tombs. The *mastabas* of King Shepseskaf and Queen Khentkawas prove that *this* shape is not decisive in ascertaining that they concern royal persons and not private.

[15] See above p. 1 with n. 5.

[16] Cf. Clarke *Archaeology*, 88-101, esp. 100. See also *LÄ*, III, 358-366, esp. 358 s.v. "Kategorien": Hodder, *Meaning*, 1-3.

that "...intelligent beings have goals and intentions which are implemented by a complex hierarchical system of information transmission." An intelligent being is a physical symbol system (PSS).[17]

There is yet a further complication. One has to make a distinction between information that is consciously or rather intentionally, and unconsciously meant to be conveyed by the maker, or culture purveyor. Conscious information may be further distinguished into explicit and implicit categories. The latter is relatively easily recognizable by the inherent or internal purveyors of the culture, but not by the outsiders. Conversely, the unconscious information is precisely what may be detected by the latter, for instance, by making closer inventories of certain accents or features in, preferably, different systems of artefacts.

A simple and concrete example from our own culture may clarify this. All aspects mentioned in the previous paragraph are present in a certain make of a modern battery-operated quartz wristwatch indicating time in hundredths of a second by means of a digitalized display. The consciously and explicitly meant information is that the primary function of the instrument is to indicate time. Explicit, too, is the fact that considering the small size this function can be effectuated at only a short distance from the eyes, in contrast to a long-case pendulum clock. The wristband also demonstrates that it is worn on the body, while the differences in size of both the case and bracelet refer implicitly to the different sexes: small = female, big = male. The fact that the male/female wearer shows the environment by no longer using a watch with an analogue dial[18] that he/she is keeping pace with modern times, he or she is also conveying implicit but still conscious information. Additionally, the used materials and especially the make refer implicitly, considered from the primary function, to the social status of the owner/user. The "emotional" value of the various makes of more or less equal quality is especially difficult to grasp for the external observer/researcher.[19]

The information that, by definition, is imparted implicitly *and* unconsciously by the maker/user, but for one reason or another may be explicitly and consciously looked for by the external researcher, concerns the fact that any watch of any type and make testifies to the general state of technology in the culture

[17] E.M. Segal, *Archaeology* in: Renfrew, Zubrow, *Ancient Mind*, 22-28, esp. 23.

[18] For convenience sake the fact is left out of consideration that presently, after the first wave of digital displays (note the modernizing use of words: after all, a dial is a *contradictio in terminis* for this type of watches), which by definition operate on batteries, there are watches available that are looking outwardly "old-fashioned" with an analogue dial, but are still running on a battery.

[19] Over four years after writing this paragraph, a Dutch newspaper with a great cultural and scientific interest (*NRC-Handelsblad*, 12 November 1998, *Agenda*) devoted a full page to the modern watch culture, addressing precisely all aspects mentioned here and even more (especially the increasing number of technical gadgets). The issue was jokingly summarized: "Only a wristwatch with an inbuilt microwave oven does not yet exist".

under investigation. The researcher can further substantiate this by the inclusion of other artefact systems in his study, such as compact disc and video-players. Here too, digital numbers are omnipresent, which also indicates, beside specific information concerning the apparatus itself, time. The scale of distribution of these high-tech artefacts not only offers an insight into the degree to which this sort of technology has pervaded modern Western society. It reveals, equally unintentionally, by means of the sophisticated mechanisms the general – all but obsessive – need for precision in measuring, that is "controlling" (any length of) time.[20] Here it concerns a purely utilitarian measurement of time.

Something quite different, however, is going on when, contemporaneously with these artefacts, just before the end of a graduation ceremony, the beadle of the Leiden University in full robes of office, consults a sturdy pocket watch on a chain with finely worked hands and Roman numerals, which is immediately followed by his proclaiming "Hora est". This is, from the point of view of the latest state of technology, an anachronistic measurement of time. This action is determined by traditional or aesthetic aspects and reveals – again unconsciously – an ambivalent attitude to the phenomenon of time. The fact that man is "inconsistent" concerning the phenomenon of (the measurement of) time tells something important about his cognition and psyche, and allows a glimpse of his various language games (cf. p. 67ff.), respectively form(s) of life (cf. p. 85ff.).

Now, the interesting thing is that such fundamental, psychologically, deep structures can be made explicit by internal culture purveyors only by self-contemplation of a certain aspect of their own culture, whereas this may be immediately clear to an external observer, even at first contact. Consequently, the confrontation of a Westerner and his quartz watch with a member of the San tribe[21] will demonstrate unequivocally to both that, in order to honour an arranged appointment at the same time, say at noon the next day, the one will observe the position of the sun and the other a peculiar object on his wrist. The Westerner will arrive punctually, whereas he will meet the other who has already been waiting for maybe a quarter of an hour or who may arrive a quarter of an hour late, because in both cases the sun had reached its approximate zenith in the sky. The Westerner's casual statement that he arrived so punctually owing to his Rolex will be totally meaningless to the San. Cogently, it will be quite obvious to him that between both of them there exists a fundamentally different attitude with regard to the notion of "exactly" or "punctually" in relation to time.

[20] The increasingly sophisticated stopwatches and digital time registration devices at sports events are the most excessive examples of this phenomenon. Cf. on this subject also Prigogine, Stengers, *Order*, 16-17 and Balandier, *Le désordre*, 165.

[21] The word Bushman should be avoided because of negative connotations.

This simple example demonstrates that artefacts, in principle – provided there is enough context – can, initially, inform about the *material* culture of people, but in the second instance about *immaterial* aspects of the same culture as well. Adding the chronological dimension to this results in cultural history. However, this itself is determined in the last resort by the mentality of the culture purveyors. The study of its development concerns the field of the history of mentality[22].

It will be obvious by now that the very sophisticated data concerning the given examples that are available to us, owing to their embedding in our own contemporary culture, are only very partly present, or may have even been completely absent, in a dead culture as remote in time and place as the Ancient Egyptian. Yet, one should be conscious of the fact that in principle comparable subtleties are likewise potentially present in the material, in this case the artefactual, remains of this complex culture, and in *any* culture for that matter. This takes us back to p. 7: which method(s) and theoretical starting-point(s) provide us with both maximum knowledge and insight concerning the group of people who produced "the elite tombs of the Old Kingdom in the Memphite area" without drawing unfounded conclusions?

[22] See Hodder, *Meanings*, esp. 1-2; Panofsky, *Iconography*; Vovelle, *Idéologie* (the Dutch edition *Mentaliteitsgeschiedenis* was used), and below p. 58, 82, n. 74.

Was wir zur Erklärung der Bedeutung, ich meine der Wichtigkeit, eines Begriffes sagen müssen, sind oft ausserordentlich allgemeine Naturtatsachen. Solche, die wegen ihrer grossen Allgemeinheit kaum je erwähnt werden.

What we have to mention in order to explain the significance, I mean the importance, of a concept, are often extremely general facts of nature: such facts are hardly ever mentioned because of their great generality.

Wittgenstein, Philosophische Untersuchungen,
addition 142-143

3. FUNDAMENTALS:
TERMS, THEORY AND METHODS

3.1. TERMS

3.1.1. Elite Tomb

To prevent ambiguities and other vagaries arising in methodological and/or theoretical matters, it is necessary to develop and use a terminology that is defined as strictly as possible.[1]

Since, as is evident from the title, the artefact "elite tomb" is the "archaeological fact"[2] that forms the basis of our study the first step has to be to define this more closely. In an earlier publication in which the quantitative question is central, the word "mastaba" was still used indiscriminately.[3] Strictly speaking, this word is unsound, because it is a purely external and formal description of an architectonic superstructure functioning as a tomb. It does not say anything about the interior, although one is clearly dealing with two types: a(n) (almost) massive superstructure (with or without an internal cult chapel) and one broken up into various room and corridor sequences (cf. figs. 5-8, p. 54-57.[4] Since mastaba simply means "bench" (see p. 10), the term does not reveal anything of the hidden physical complexity. Cogently, the term mastaba has become so primarily connected with the Old Kingdom that, if one speaks subsequently about the iconography of the mastabas, the suggestion is unintentionally made that in rock tombs, which are predominantly connected with the Middle Kingdom, a different iconography might occur. This would be an unfounded assumption as fig. 1 shows that contemporaneously with the mastaba, although to a lesser degree, the rock tomb was indisputably important in the Old Kingdom. It follows that the same iconography is found there. So, actually, the phrase "iconography of the mastaba" implies the representations as found in the tomb complexes that is the "real" mastabas and/or rock tombs, of the cultural upper class.[5] The substantive "elite", in both senses of "a segment or group regarded

[1] See Clarke, *Archaeology*, 23-30.
[2] See for an extensive commentary on "archaeological facts", o.c., 13-19.
[3] Van Walsem, *Mastaba Project*, passim.
[4] *LÄ*, II, 829-830, s.v. "Grab",E-G; III, 1214-1231, s.v. "Mastaba".
[5] This is clearly different from the grave as a simple pit or hole in which the mass of the population was buried. In any case, one should bear in mind that the majority consists of undecorated tombs, cf. Fitzenreiter, *Totenverehrung*, 98, n.7 and Herb, *Wettkampf*, 41, n. 68. The latter gives

Fig. 1. The tomb of Niankhkhnum and Khnumhotep, Saqqara.

as socially superior" and "a minority group or stratum that exerts influence, authority or decisive power",[6] most adequately defines this section of the population.

Finally, in order to preserve neutrality, our word "tomb" is that best in keeping with the Old Egyptian *is*, that may refer to both the royal tomb and the tomb in the group under discussion.[7]

a ratio of 9:1 for undecorated, respectively decorated tombs, but without reference to the specific data on which these numbers are based. For the unity in spatial programme between rock tomb and mastaba, see Brinks in *LÄ*, 3, 1230, with n. 70, s.v. "Mastaba".

 [6] *Webster's Dictionary*, I, 736.

 [7] Pyramid Text 216b (edition Sethe, *PT*) is the oldest (King Unas, end 5th dynasty) reference to the royal tomb using this term and showing a "mastaba" as a determinative. The word *i'*, *WB*, 1, 40,3, has been used only once in PT 616 (oldest variant in Teti pyramid) as a term for the royal tomb and is thus later than *is*. It is not inconceivable that the word *is* (*WB*, 1, 40,18-24) is etymologically related to *ist*, "boundary stone" (*WB*, 1, 40,17), although it does not occur before Unas. After all, a tomb may be understood as the monumental "boundary" between two spheres of existence (see for the difference p. 35ff.): those of the living and of the dead. It would seem that, in the Old Kingdom, *is* was the most neutral word for "tomb" (of the elite).

In summary, an elite tomb can be defined as: an architectural complex completely or partially free-standing, respectively cut from the rock, consisting of one or several (substantial) space unities, which is inextricably and consciously connected with the mortal remains of the elite, and (was planned to be) provided with decoration, that is iconography and/or texts.

Beside the mere size of the tomb, which is already sufficiently telling, texts in conjunction with titles once more explicitly indicate the social position of the owner.

*We should always ask the iconologist to return to base
from every one of his individual flights, and tell us whether
programmes of the kind he has enjoyed reconstructing can
be documented from primary sources or only from the work
of his fellow iconologists. Otherwise we are in danger of
building up a mythical mode of symbolism, much as the Renaissance
built up a fictitious science of hieroglyphics that was based on a
fundamental misconception of the nature of the Egyptian script.*

Gombrich, *Aims and Limits of Iconology*, 483

3.1.2. Iconography/Iconology

After the functional definition and the social specification of the artefact that in conjunction forms the material base for the application of decoration, the term "iconography" deserves closer attention. The Greek *eikoon* means "likeness/image/representation"[8] and *graphein* "to describe/inscribe/write down".[9] This makes iconography an art historical activity that, in first instance, describes both three- and two-dimensional representations according to their external or *natural* appearance, covering the area of *artistic motifs*. For instance: a relief showing a large figure in a two-wheeled chariot drawn by horses riding into a chaotic mass of armed people represents "a battlefield" = "a war". The interpretation is based on practical experience, and the former's correctness on the "history of style", i.e. knowledge of the chronologically varying ways of representing *objects* and *events* by *forms*.

Subsequently, the *conventional* subject matter (covering the area of *images, stories, allegories*) is established by analysis of literary sources on *themes* and *concepts*. The scene, then, appears to represent not only the *theme* of the historical battle at Kadesh led by the New Kingdom pharaoh Ramses II (19th dynasty, ± 1275 B.C.), but also the *concept* of the invincibility of Egypt engendered by the co-operation between the god Amun and the king. The correctness of the conclusions is confirmed by the "history of types", i.e. knowledge of the chronologically varying ways of representing *themes* and *concepts* by *objects* and *events*.

Erwin Panofsky (1892-1968), who conceived the terminology used above,[10] took the first two stages a step further. The iconographic analysis is followed by an *iconological interpretation*, which is actually an iconographic synthesis in which one tries to interpret, in Panofsky's terms, the "intrinsic meaning" or "content" covering the area of *"symbolical" values*. This interpretation may be reached (depending on the material available) by the use of *synthetic intuition*, which has to do with familiarity with the "essential tendencies of the human mind". This is conditioned by the investigator's psychology and *"Weltanschauung"*. The correctness of this deepest interpretation is based on the "history of *cultural symptoms* and *"symbols"* in general", which shows the chronologically varying expression of "essential tendencies of the human mind by specific *themes* and *concepts*".

Although Panofsky did not specify his "essential tendencies of the human mind", one should think of the varying behavioural expressions of psychological and cognitive notions and attitudes towards: self-awareness, self-maintenance

[8] Lidell, Scott, *Greek-English Lexicon*, 485.

[9] O.c., 360.

[10] It concerns the terms in italics of the preceding and present paragraph. See Panofsky, *Iconography*, for an extensive discussion.

and control with regard to the external world, status sensibility, individuality vs. collectivity, typical vs. specific, time relations, divine powers and the like. Very rarely, as we have seen earlier (cf. p. 12), is the culture purveyor himself, though, conscious of (all) these deeper generalities.

Several of these tendencies are met in the above example. There appears to be a great differentiation and specification of data in representation and/or texts, such as exact location, time, military circumstances, identification of persons, prayer offered by Ramses to Amun and so on. This is not restricted to Ramesside war scenes, but appears to occur *generally* in the (later) New Kingdom: in language (New Egyptian used a heightened frequency of specific indications of tense), in literature (the largest number of genres, love poetry), visual arts (largest number of statue types), religion (increase in the number of Books of the Underworld in royal tombs together with expressions of "personal piety" in and outside the official channels and the like). More than ever, the general tendency is an overtly stronger feeling for and consciousness of (historical) time and the individual.[11]

The example shows that, in principle, any cultural product, apart from its explicit meaning, encompasses implicit other features or traits, symptomatically present in various degrees, reflecting a general cultural reality. At the point of transition from the stricter interpretation of the primary iconographical source to a broader, culture historical embedding, iconography, in Panofsky's terms, converts to iconology. Although developed for Western art history, in principle, because of its universal character, Panofsky's method is applicable to any culture.[12] However, he does not, or hardly touches upon some fundamental and implied problematic issues at the epistemological level. This omission is what the second part of this chapter will investigate.

[11] Cf. Assmann, *Entdeckung der Vergangenheit*, 305ff.; for the most recent bibliography on the battle of Kadesh, see Vandersleyen, *L'Égypte*, 525, n. 1.

[12] Cf. also Osborne, *Art*, 555, s.v. "Iconography" and "Iconology". Notwithstanding some fundamental criticism of (a too speculative application of) Panofsky's method by Liebmann, Dittmann and Pächt in Kaemmerling, *Ikonographie*, 301-376, and by Gombrich, *Cultural History* (mainly of Panofsky's considering the "content" as an all *explanatory* supra-human entity, more or less identical with the Hegelian "spirit of the age"), it remains – as long as it is embedded in the other approaches and aspects discussed in the present study – the best methodological approach we have. The complete lack of the name of Panofsky in the lemma "Ikonographie" in *LÄ*, III, 128-137, once again, underscores the "insularity" of Egyptology, noticed by Redford in his *Historiography*, 10-12. However, Seidlmayer, *Ikonographie*, 245-247, mentions him in n. 57 and acknowledges his approach as extendible to archaeology as well.

...Der Begriff der übersichtlichen Darstellung ist für uns von grundlegender Bedeutung.
Er bezeichnet unsere Darstellungsform, die Art, wie wir die Dinge sehen.
(Ist dies eine 'Weltanschauung'?)

...The concept of a perspicuous representation is of fundamental significance
for us. It earmarks the form of account we give, the way we look at things.
(Is this a 'Weltanschauung'?)

Wittgenstein, Philosophische Untersuchungen, 122

3.2. THEORY AND METHOD

3.2.1. Classification

Here we are faced with the problem that the word "iconography", like the word "tomb", can be provided with a qualifying adjective, for instance, "religious", respectively "elite". This implies a specific interpretation after the description at the level of analysis. "Religious representations" imply "non-religious" ones, just as "non-elite" or "modal tombs" are the antipodes of "elite tombs". It concerns the categorization and classification of data, which is, and not only in my view, one of or rather *the* most central and cognitive issues both in science and in human life and culture as a whole.[13]

The study of Ancient Egyptian iconography concerns our classifying the total "cultural reality" of Ancient Egypt for as far as it has been left iconically in its material culture. Therefore, its interpretation, one which does maximum justice to the message concerning their observed and interpreted reality as meant and experienced by the *makers* – in my view the main task of Egyptology – depends heavily on classification. Interpretation of reality is the result of the inseparable and, in this order, series of acts: observation –> description –> classification (= analysis) –> interpretation (= synthesis). The dividing lines between the components have been drawn here more sharply than they actually are for the sake of clarity.[14]

The foregoing implies that all human knowledge about mankind's external reality is based on empiricism which, very strictly taken, results in conclusions or knowledge about this reality in a varying[15] degree of induction. In practice,

[13] Most instructive concerning the far-reaching consequences of the centrality of this issue is Lakoff, *Women, Fire*, xi-xvii; 5-11 (e.g., p. xvi: "It matters for our understanding of who we are as human beings and for all that follows from that understanding"); cf. also Adams, Adams, *Typology*, ix (first motto), xv-xviii, xxv;. Hodder, *Meanings*, 7-8; Weeks, *Art*, 60ff.; Kemp, *Ancient Egypt*, 1-3, Bolshakov, *Double*, 17-18. Here, too, it is noteworthy that the *LÄ* did not include a lemma "Klassifikation", as Frandsen observes as well s.v. "Tabu", *LÄ*, VI, 137, n. 17, but it did include "Kategorien", cf. above, p. 11 n. 16. The importance of Lakoff's studies is fully acknowledged by Frandsen's, *Categorization and Metaphorical Structuring*. Finally, one has to realize that scientific classification is actually a derivative of an indispensable necessity of life.

[14] The case of the hexagonal shapes of p. 9 has already demonstrated that description and classification merge smoothly. The birds in fig. 3 – themselves already again a separate class in respect of the remaining items represented – made it possible to designate them in both cases (figs. 2 and 3) as hexagonal *nets* (simultaneously comprising description and classification), which at the same moment implies an *interpretation* in relation to the *object* depicted, but does not yet interpret the entire *scene*. In short, a *hierarchy* of *levels* of interpretation is concerned here. Hierarchy is also stressed by Bolshakov, o.c., 41, 43ff. Cf. also Panofsky, *Iconography*, 67, about the vagueness between the phases of research he distinguished.

[15] Pure induction or deduction is non-existent in scientific *practice*, see Adams, Adams, *Typology*, 60-61, 67, 281-282; Hodder, *Meanings*, 2, 6. See also below p. 34. One might also say that man on, literally, cosmic scale is always inducting, while on a local scale he may both deduce and/or induct, depending on the data available.

one can only take samples from the total of reality, from which one tries to draw conclusions about the entire reality, resulting in what I call provisionally – in a literal sense – a "Weltanschaaung" or world-view. This is even true of the so seemingly exact natural sciences.[16]

In other words, all human knowledge is in essence interpretation and ordering of (sub)-sets of classified data from the surrounding reality, obtained and experienced by sampling. Sampling is by definition a statistical activity. It means that the "truth" of subsequent statements about reality can never be absolute, because the total population from which the samples are taken remains unknown. Therefore, statistics never prove statements. Only the probability of a statement can be calculated. Still, when thinking of arithmetic or calculation it is important to be aware of the fact that, indeed, man is the measure of all things.[17]

[16] Cf. Clarke, *Archaeology*, 469-470.
[17] Even the most sophisticated arithmetical model remains a man-made construction and concept. See p. 41ff. for further statistic aspects.

...Wie wir aber die Worte nach Arten zusammenfassen, wird vom Zweck der Einteilung abhängen,- und von unserer Neigung...

...But how we group words into kinds will depend on the aim of the classification, – and on our own inclination...

Wittgenstein, Philosophische Untersuchungen, 17

3.2.2. Structures of thinking

The necessarily incomplete knowledge about reality, inherent in man's own position in it, implies incomprehension and saddles him with an existential insecurity, respectively doubt, or perhaps more appositely anxiety. Incomplete knowledge about an object or (immaterial) phenomenon, reality, actually makes it uncontrollable and hence existentially not only unsafe but in many cases actively threatening: natural disasters, illness, and death.[18] Consequently, *the* characteristic feature of each individual and, collectively, of every culture is the irresistible pursuit of maintaining oneself, that is (the feeling of) having "power", by controlling or rather mastering (= having knowledge of)[19] the material and immaterial worlds of existence – even if this control is actually only illusory. By definition this appearance is caused by the only *partial* control, which is the inevitable outcome of mankind's given subordinate position in the interaction man versus reality. Pertinently, the degree of the control pursued appears to differ: the San (cf. p. 13) provide themselves with enough material culture to subsist. Western mankind launches space probes for collecting data that should give further answers to fundamental questions about "big-bang" cosmology.[20]

The fact that we call in our technology for help in answering cosmological problems does not mean that we should consider ourselves as being more intelligent or different in basic psychological processes, respectively mechanisms, or dealing with an – essentially – different reality to that of the San or ancient Egyptians. It concerns a different attitude or rather mentality[21] in respect of this matter, namely, having no peace, nor being satisfied with our knowledge of existential issues.[22] This has been propelled ever

[18] For the Egyptian consciousness on this matter, see *LÄ*, II, 479-483, s.v. "Gefährdungsbewusstsein".

[19] This aspect also strongly emerges in *LÄ*, III, 260-261, s.v. "Jenseitsvorstellungen" (o.c., 252-268). Even the gathering of at first sight useless knowledge, just for a person's interest in knowledge as such (exemplified, for instance, by the many quiz programmes on television), results in existential "power", manifested by the respect for one's knowledge shown by other individuals not having (this specific) knowledge. So the bottom line is that ultimately any knowledge has repercussions on one's (social) status, that it is a means of maintaining oneself, in reality.

[20] One should consider the fact that the Egyptians were also very much interested in cosmology and in more than that, as Englund correctly remarks in her *Gods*, 8: "Egyptian theologians were first and foremost interested in cosmology…Actually it represented the thinking of the elite…This does not correspond to what we…call religion. It embraces not only matters of faith but also philosophy, psychology, and theories about the functioning of the world and society…in a period when science, philosophy and religion were not yet separate activities taken over by different disciplines". Cf. also, Finnestad, *Religion*, 73-74.

[21] Cf. Bolshakov, *Double*, 15-17. Junge takes the same viewpoint in *Sinn*, 47, in respect of the (almost) complete anonymity of (great) artists in Egyptian culture, in contrast to ours.

[22] It does not mean, that the Egyptians were, by contrast, (completely) satisfied with an idea once formulated about fundamental questions of creation, life and death. For instance, the evolution of the Pyramid Texts and Underworld Books in royal tombs offers convincing proof of the

since the pre-Socratics[23] by our irresistible inclination to observe and consider phenomena from a distance. Such a "perspective" way of looking and thinking increases our "cone of observation". This draws all kinds of other aspects and/or phenomena into the classification and interpretation of reality, which would not be able to play a role in a system (closely) concentrating on only one phenomenon, such as seems to have been the case in the Egyptian culture, for which the term "aspective" is a useful adjective.[24]

It is not only very tempting to try to organize the directly observable reality into one coordinating, consistent structure but – for modern man – it is particularly difficult. For, nothing is made "definitive" through the mobilization of technology and its resulting, speedy, never-ending flow of new information. The unavoidable consequence is a maximum uncertainty in respect to the answers about the foundations of the existential reality. Note the paradox: a foundation is characterized by certainty or stability, for it is the base of a building or world-view, but Western culture in particular makes it seem that this foundation appears to rest on quicksand because of its insatiable desire to keep on asking. The *Leitmotiv* of Western man's structure of thinking and dynamics by which he approaches his external reality is his refusal to reconcile himself to a given answer about a certain state of affairs. Proposition 5.634 in Wittgenstein's *Tractatus logico-philosophicus* puts this aptly into words: "Alles was wir sehen, könnte auch anders sein. Alles was wir

opposite. However, they have never (demonstrably) been proved to have been able or willing to use technology as an aid for testing their own conclusion *experimentally*, nor indeed those of others, concerning the fundamentally ontological questions. Therefore, their cosmologies have not passed the stage beyond being predominantly or purely *speculative* constructs which within their own frame of thinking, anyway, are very rational (= mainly by reasoning without feedback to or from physical reality).

[23] Cf. Hamlyn, *Western Philosophy* (Dutch edition), 14ff.

[24] Cf. *LÄ*, I, 474-488 s. v. "Aspektive"; IV, 987-88, s.v. "Perspektive". The opposition between the two terms seems more absolute than it really is, as is convincingly exposed by Junge in *LÄ*, III, 371-377, s.v. "Kausales Denken", respectively by Henfling, o.c., V, 1133-1138, s.v. "Spekulatives Denken".

It is incorrect to assume or postulate that modern (read: Western) man is thinking *exclusively* perspectivally/causally/rationally, in contrast to "primitive" man who would think *exclusively* aspectivally/mythically/magically. Rather, it concerns a "bipolar continuity" within *any* system of thinking in which one of each pole is intermittently dominant, without completely eliminating the other one; cf. also p. 34 with n. 32. Very enlightening on this are chapters 5-6 in Oosten, *Reason and magic*, 53-90.

The essence is that, by linking to the "perspective pole" of the (repetitive) experiment (cf. n. 22), the interpretations of analysed observations are integrated, like building blocks, into one coherently hierarchized "pyramid of knowledge". The latter is "objective" to such a degree that it practically enforces a subject, who *consequently* applies the rules of thought used, to revise a former deviant (and thus at least partly mistaken) point of view. In other words, the "direction of thinking" is both horizontal *and* vertical. However, the primary *speculative* (partial) interpretations and/or constructs (cf. n. 22), in essence, remain side by side as "bricks" without hierarchy. Therefore, the base of knowledge can hardly be extended differently but (chiefly) horizontally, and not vertically.

überhaupt beschreiben können, könnte auch anders sein. Es gibt keine Ordnung der Dinge a priori". The result is the so far highest degree of culture dynamics that Western (and towards it orientated) mankind has reached, is experiencing and is driven by it. Its present dominating manifestation is the capitalistic consumer society. This is meant as an observation not as a value judgement.[25]

However, *why* (Western) man is unable/unwilling to resign himself to a *status quo* of knowledge – even if it only concerns a supposed state – on the fundamental issue, is a metaphysical question which cannot be answered unequivocally.

This rather extensive analysis above has been necessary, because one needs to have in mind an idea of one's own structure of thinking, before one will be able to speak sensibly about that of someone else.

[25] After writing this statement on the character of Western capitalist society, I discovered it was more or less repeated two years later by the American sociologist Daniel Bell in an interview, "Amerika is kleinburgerlijk" ("America is petit bourgeois") in *NRC Handelsblad*, 15 february 1996, on his main publications of which *The cultural contradictions of capitalism* is the most telling. One of his most striking statements was: "Capitalism is change, disruption, unrest. Something is possible cheaper, better, more efficient. Nothing is sacred".

The experience of death is generally human and only seldom has man reconciled himself without protest to the fact of his dying. One may consider religion, to a certain extent a grand monument to this protest.

Th. P. van Baaren, *We People* (*Wij mensen*), 167, as quoted in J.J. Oosten, *Magic & Reason* (*Magie & Rede*), 77

3.2.3. Existence/Reality

Death is experienced by human beings as the most threatening among all existential phenomena, because of its immaterial and unpredictable character.[26] Reaction within the interaction man-reality (as established on pp. 25-26) to this phenomenon is therefore one of the most central exponents[27] of human behaviour. The simple reason is that practice teaches inexorably that one cannot live in the permanent presence of the dead. So the living *have* to react. In many cultures, including the ancient Egyptian, this results – among many other gestures – in a marking of the place where a deceased has been laid to his final rest: a tomb.[28] Actually, tombs are artefacts consisting of "fossilized" manifestations of man's relationship with and attitude towards the phenomenon of death. In view of its immaterial and elusive character, death possesses by definition a "religious" charge and "thus" possible representations in tombs fall into the category "religious" iconography. [29]

However, an inspection of the walls of the elite tombs reveals that for the most part they are covered with so-called "scenes of daily life". Note, this is an Egyptological designation. It remains unknown whether and how the Egyptians themselves referred to them.[30] The representations vary from activities watched by the tomb owner, such as fishing and fowling (figs. 2, 3, pp. 35, respectively 36) to market scenes (p. 37, fig. 4, middle), sometimes

[26] Cf. p. 29 n. 18, o.c., 479.

[27] This centrality is also stressed by Fitzenreiter, *Grabdekoration*, 73. Other central exponents are those directly related and necessary to the maintenance of human life: procurement of enough food and drink; social embedding; reproduction. All other activities are derived from these.

[28] This is true of many cultures, but by no means of all. The baffling number of reactions to the phenomenon of death, as discussed in Huntington, Metcalf, *Death*, demonstrates that only the *reacting* is universal. Cf. also Fitzenreiter, *Grabdekoration*, 69-75.

[29] Statements concerning the relationship with immaterial existence, that is the, at the least, uncontrollable, if not unknowable, part of reality, are summarized in most Western languages under the covering notion of "religion". By that, they are "religious". According to the current etymology this word should be derived from the Latin "religare", "to bind (together)", stressing a non-informal relationship to a part of existence that houses at least one "divine power". However, Englund's quotation in n. 20 demonstrates that this notion is too narrow for Ancient Egypt. If one further realizes that the ancient Egyptian language has no single terms for "(divine) worship", "religion", "faith", "piety", nor for "history" or "science" (cf. *WB*, 6, sub: "Geschichte", "Glauben", "Frommigkeit", "Gottesdienst", "Religion", "Wissenschaft", are words not incorporated; see also *LÄ*, VI, 1278-1279, s.v. "Wissenschaft"), then it is obvious that they are *our* terms, based on our classification of the world. It does not automatically mean that the Egyptians were unaware of (certain aspects of) these notions (cf. the role of "knowledge" in many areas of the Egyptian culture: n. 19), but they did not summarize them in the same single word terminology/ category as we do. Osborne, *Art*, 555, s.v. "Iconography", also distinguishes between "religious" and "secular".

[30] Old and Middle Egyptian do know a "day of life" = "day in one's life", but no "life of the day" = "daily life". In New Egyptian, however, the concept of "way of life" = "conduct of life" was known, cf. *WB*, 6, 96-97, sub "Leben".

elaborated with details which may be comical, such as a monkey biting a naked boy on his thigh (fig. 3, second register from above, to the right).[31] Do they fall under religious iconography, although so far no obvious depiction of a deity and/or the king in the presence of a deity has ever been found in these tombs (cf. p. 38, IIb)? Or is it better to rephrase the question – in spite of all statements made about it in more than 180 years of Egyptology? "Is the elite tomb (that is not only its iconographic programme) based on (only) one concept, and (if so), which? Is it uniform?"

Before delving into this question anymore deeply, some other aspects first deserve to be given due consideration. In view of the fact that an artefact is an encoded sign system (cf. p. 11) as a function of the human reaction and interaction with reality or existence (p. 25ff.), it is useful to ask whether this interaction is homogeneous, and if not, to which spheres of existence (ancient Egyptian) iconography refers or may refer?

As a *biological* being, indeed, man is able to express himself about the sensory *observable* reality mainly by *recording* and *reproducing* in word and image. As a *cognitive* and *rational* being – now mainly by *interpreting* and *inducting/deducing* – he is able to express himself (again in word and image) about the intellectually *thinkable* reality.[32] The phenomena experienced by the senses during biological existence that are no tangible objects,[33] but manifestations of conspicuous[34] "powers/forces" have lead to speculations/ideas, which conclude that they (seem to) belong to an ontological sphere different from that of the biological human. The phenomenon of death that is accompanied by the sensorily observable but hardly acceptable physical disintegration of the

[31] For a parallel representation, cf. Wolf, *Kunst*, 235, fig. 201. He too classifies similar scenes under the concept of humour; cf. *OEAE*, 2, 127-130 sub "Humor and satire".

[32] It is needless to say that here too (cf. p. 30 n. 24) it concerns continuity between two polar concepts united within human personality.

[33] The water of the Nile is a tangible object. Its flood is the manifestation of an intangible power/force which is expressed by means of the water.

[34] The fact of, for instance, a wooden wheel rolling from the top of a dike to its base was (almost certainly) not "conspicuous" for an Ancient Egyptian, most probably because everything within his observation horizon moved from top to bottom of its own accord. A personification or a deity of "gravity" was literally unthinkable for him. The annual rise of heavy water (after all, wood floats on it) up against that same dike was "conspicuous", indeed, being quite aberrant from the usual course of affairs. Newton was the first to realize that the "inconspicuous" was just as much a manifestation of a force. In addition, an interesting question is whether and how the Egyptians interpreted the phenomenon of low and high tide in the tidal area of the Delta. After all, the real causes of the externally identical rise of the water level in the (estuaries of the) Nile are completely different to those of the flood. The fact that low and high tide occurred daily and were only very locally confined, in contrast to the flood which happened only once a year, but was visible throughout the entire country, may be the reason that the latter is met with in the material sources whereas the former is not. On the other hand, the tidal movement is (very) limited in the Eastern Mediterannean, so the entire phenomenon may have passed unnoticed.

individual is again a reason to adduce the supposition that it concerns a transition to another sphere of existence.[35]

Accepting this as a base for the analysis and interpretation of Egyptian iconography, the foregoing makes it necessary to distinguish between different "spheres of reality".

Fig. 2. Wall in the tomb of Ptahhotep, Saqqara

[35] Cf. *LÄ*, III, 252-267, s.v. "Jenseitsvorstellungen", for the different spheres of existence in the sources.

It is peculiar to observe that, if one takes the most essential characteristics of the opposition life-death as a conscious versus a definitely unconscious (distinguished from sleep, unconsciousness, apparent death) existence of man, the unconscious mode appears to be so frightening for and unacceptable to him, that he cannot do without all kinds of speculative constructs which yet, somehow, stipulate an immaterial *conscious* continuation of existence of (at least part of) his being. The base for this existential fear lies, in my view, in the empirically observable, *definitive* character of the *no longer* conscious (continued) existence in the *known* reality. Apparently, one does not realize that there is not a single objective fact available that even suggests a difference between the *character* of the *not yet* conscious being *before* biological existence and the *no longer* conscious being *afterwards*. In my opinion, the most plausible reason for this is that "not yet" implies (= gives hope for) a (potential) realization of "something" (the biologically experiential existence that is), while "no longer" excludes this. Tacitly one concludes from this that it concerns a difference in essence or character. However, if, in respect of an individual, both spheres of existence are no more different from one another than their being connected via the biological intervening, conscious phase of that same individual, it stands out that (many) more complex constructs have been conceived for one sphere than for the other. From his *experience* man appears to be better able to make himself an image of what possibly follows during his "no-longer-living" than of what precedes during his "not-yet-living" – even if there is equally little ground for the former as for the latter. A. Lacy in Honderich, *Philosophy*, 178, s.v. "death" very nicely summarizes the foregoing: "Fear, it is true, concerns only the future, but we do not seem to regret those past aeons".

Fig. 3. Wall in the tomb of Niankhkhnum and Khnumhotep, Saqqara

 I. *Material* reality. Henceforth the term *real* reality (in the sense of being sensorily observable and intellectually realizable (= thinkable) by an individual during his lifetime) will also be used,[36] see, for instance, the scenes of figs. 2-4.

 II. *Immaterial* reality. This can be farther distinguished into:

[36] The substantive "matter" primarily implies the *physicality* to which the adjective "material" refers (cf., e.g., the opposition between the material (= possessions and so forth) and immaterial (acts, experiences, ideas) side of someone's existence). "Reality" refers to the (objective) *possibility* or rather *"existibility"* (and thus by definition to the material (expression)) of something, but does not, therefore, exclude the "immaterial" from its semantic field, because, in the example above ("…someone's existence"), the word "existence" can be replaced by "reality". In other words, "reality" and "matter" form a complementary pair in which the immaterial (for instance, an act) or the abstract ("love", expressed by the acts of physical individuals) do remain intangible (= immaterial), but are not denied (declaring them "unreal"). Since in the visual arts by nature no abstracts can be represented with great facility, thus in this context the word "reality" stands for the material (in the sense of tangible/visible) aspects. Twentieth-century, pure, abstract art falls logically under immaterial, that is ideational reality, see IIb, p. 38.

 "Unreal" primarily refers to the *impossibility* or rather *"non-existibility"* – the denial – of something, irrespective of being material or immaterial. Thus "impossibility/inexistibility" and the non-existent substantive "immatter" (which is telling) cannot form a complementary pair. Hence, in the continuation of the discussion of the subject "reality", the adjective "unreal" is unusable.

Fig. 4. Wall in the tomb of Niankhkhnum and Khnumhotep, Saqqara

IIa. ideological (in the sense of, on the one hand, experiential, on the other hand of exclusively conceivable) configurations, for instance: the king conquering his enemies alone and/or being represented on a very large scale; or the tomb owner, being represented on an unnaturally large scale, observing all kinds of scenes (cf. fig. 2).[37]

[37] Here too the matter is complex. One has to distinguish, between what I would like to label "(part of) existence *reproducing* (= visual/visible)" ideology (for instance, expressed by a larger than natural representation of the most important person(s)), and "(part of) existence *structuring* (= invisible)" ideology, creating, for instance, a body of thoughts about the king's power that both reflect and (may) combine reality ("head of the army") with unreality ("superhuman",

IIb: ideational (in the sense of during life not sensorily observable, but exclusively imaginary) configurations, for instance: deities/kings alone or in the presence of ordinary people.[38]

In conjunction with the division made above of the iconographic "field" in respect of reality[39], one should keep in mind that (modern, purely abstract art (cf. n. 36) excluded) all ideational and/or ideological iconography is composed of elements which in the first instance are directly – and literally as a matter of fact – self- or inwardly referential.[40] Outward referential or metaphorical elements can be made explicit not only directly, as discussed, via the means of representation, but also via added texts. The conclusion, therefore, is that scenes, characterized in this way, have by definition an ideational/ideological

"always victorious" [the latter condition may actually be true for a short reigning king!]). Thus the first, existence reproducing ideology, concerns only "technical" ideas about *how* the idea *that* the king is by nature invincible can be visually represented, while the latter, existence structuring ideology, concerns the incentive for these representations and their (potential) adaptation and change over time.

Now, the distinctive feature of ideological representations is that elements confirming the idea (= positive) are emphasized, while disaffirming or at least undermining ones (= negative) are left aside. Examples of confirmation are, for instance, the pose, the (very) large representation of a person and the acting alone by the same, while the disaffirming is "expressed" by omission: the first relief of a beaten Egyptian king has yet to be found, just as the representation of a sick tomb owner (see *LÄ*, I, 555- 559, especially 555, s.v. "Aufzeichnungsbedürfnis und -meidung"). The dwarf Seneb is the only *very highly placed tomb owner* showing an obvious physical handicap (Dasen, *Dwarfs*, esp. 40, 126-130), simultaneously representing the exception that confirms the rule, and expressing a strong individuality ignoring tradition; see below p. 97 on individuality with regard to (almost) unique scenes. This is the essential difference with *real* representations where positive and negative, in the least, may be joined: in one tomb one sees only perfectly healthy labourers, in another they are mixed with people showing various kinds of physical infirmities. Concerning this point, one is apparently free in real representations, in contrast to ideological (and ideational) ones.

The preceding may be phrased differently as: "reproducing ideology" does not determine the *content* of "existence structuring ideology", but (the degree of complexity of) the latter does determine *which* reproducing means are used *how*. For instance, the (super)human power of the conquering king can be expressed as: a) two (virtually) equally large persons, of which one is in a subordinate pose (Schäfer, *Principles*, pls. 8-9 (Narmer palette), 11 (ivory label of Den)), or b) the king (much) larger and alone, plus a group of three or many persons in a subordinate position (o.c., fig. 142, 239). The complexity of the difference in size becomes clear when one compares fig. 4 (p. 37), lower part, to the right, with royal iconography: the row of large heads above the board of the ship does not express a difference in status (= ideology) with the much smaller figures near the mast: space is the decisive, "technical" "artistic" factor.

[38] Consider, for instance, the New Kingdom vignette of the Book of the Dead, spell 125: the heart of the owner, himself present and fully dressed, is weighed against the ostrich feather, symbolizing the goddess Maʿat in the presence of deities. Note that in the Old Kingdom only kings could be represented in the presence of deities, never private persons, who are also not found depicted in the presence of the king before the New Kingdom; cf. also Van Walsem, *Iconographic Programmes*, 1208-1209.

[39] Cf. n. 33 in Versnel, *Reflections*, quoting Rosengren (o.c., n. 2): "It makes better sense to start with a distinction between ordinary reality (or realities) and extraordinary reality (or realities)". Cf. in this light also Seidlmayer's views in *Ikonographie*, 245-252 and Fitzenreiter, *Grabdekoration*, 76-77, esp. with n. 30, differentiating between "sacral" and "profane".

[40] This is also pointed out in *LÄ*, I, 138, s.v. "Alltagswelt und Heilige Welt".

meaning in a "directly evident"[41] way. Scenes missing these attributes *may* have this meaning, but not necessarily so. Consequently, here too *degrees* of outward referential meaning(s) are what are concerned. Other gradual aspects will be discussed on pp. 47, n. 48, 49, 58-59, 77, 81, and 93.

[41] It is neither the time nor the place here to go into the complex philosophical issue of the terms "directly/indirectly evident", see for this Chisholm, *Knowledge*, Chs. 2 and 4. In the present context it is understood that for everyone, professional or layman, it is directly evident/clear that a depiction of the king who *all alone* grabs with his left hand some scores of armed enemies by their hair, and holding a club in his right hand being on the verge of smashing their skulls, *cannot* be but an ideological scene. On the other hand, in the case of, e.g. the hexagonal nets of figs. 2 and 3, it is for both the professional and layman, at best, *indirectly* made evident that here it (might) concern(s) a reference to the tomb owner's control over the powers of chaos, through reference to similar symbolism of both fishes and fowl only known as such since the Ramesside period; cf. Gamer-Wallert, *Fische*, 73-74.

Statistical methods are thus seen as an addition and a corrective to traditional classificatory practice rather than as heralding a radically new methodology.

Adams, Adams, *Typology*, 291

First, statistical significance is a matter of degree...

Idem, 292

3.2.4. Statistics

3.2.4.1. General Observations

However, it is first pertinent once more (cf. p. 26) to underline the eminent role of statistics in no matter what kind of knowledge is being pursued. The fundamental difference between the exact sciences and the non-exact social sciences is the fact that the former describe stable or inert matter, and the latter the behaviour of humans. Therefore, in the former it is possible to make statements with a much higher degree of probability and, as a direct concomitant, predictive power than the social sciences. To such an extent indeed it has been the custom to speak of the laws of nature, which, although only applicable to their specific area of validity, imply a complete determinism or lack of freedom. The phenomenon of "free will" present to a high degree in man is literally the spoilsport in the social sciences.[42] However, the lower probability power of the non-exact humanities does not justify a complete abandonment of effort to achieve by means of mathematical, that is statistical, procedures, a getting of a grip on patterns of behaviour (in the widest sense of the word) of what seems at first sight such an incalculable object of study as a human being. In the present case of iconographic study, statistics – besides Panofsky's corrective principles – may underpin the results obtained, at least quantitatively. The, alas, insurmountable handicap of the impossibility of the original culture purveyors being directly able to verify or falsify our conclusions and statements is no excuse for setting statistics aside. By using statistics, Egyptology and each of its branches only increases its authority in respect of other social sciences, such as sociology, psychology and cultural anthropology, which have worked successfully with statistical methods for a much longer period.[43] After all, the common subject of research of these areas of science is the human being and its behaviour, either "fossilized" in the past or "living" in the present.

Leaving aside for the moment the details of the population structure (cf. p. 44, 45-46) of the present iconographic material, certain points need to be indicated briefly. In statistics there is a distinction between descriptive and inferential statistics. The results of the former are based on deductive reasoning from a population (= a set of identical elements) that is completely known. The second uses a (random) sample (= a part of a population) while supposing that it is on average a correct reflection of the entire population on a smaller scale. In

[42] For the problems of the human "free will", see Honderich, *Philosophy*, 292-293, s.v. "Freedom and determinism", 910-911, s.v. "Will"; Gregory, *Mind*, 147-148, s.v. "Choice, biological", 190-192, s.v. "Determinism and free will", 383-386, s.v. "Intentionality".

[43] An exemplary statistical assessment and analysis of Cherpion's dating criteria in her *Hypogées* is presented in Seidlmayer's *Stil und Statistik*. Faltings, *Keramik*, passim, uses statistical methods for treating and presenting data in (bar) graphs as well, while Bolshakov, *Double*, Van Elsbergen, *Fischerei*, and Herb, *Wettkampf*, use only tables. For the problem of dating, cf. p. 98, n. 141.

other words, one method generalizes from the overall or general to the partic-
ular (without being disturbed by unknown factors: deduction); the other tries
to draw general conclusions from the particular (by definition disturbed by
(un)known factors: induction).[44] Which statistical line(s) of approach should
be taken in the analysis of the iconography of the elite tombs at issue?

The fact that an Egyptologist is only working with a part of all the once
extant elite tombs of the Old Kingdom, even within a limited area such as the
Memphite, implies that he is dealing with a sample of that once extant popu-
lation.[45] Considering the character of the sample this suggests that it concerns
a *random* instead of, for instance, a *systematic* sample where observational
data are located at equal distances, for example by choosing every fifth or
tenth elite tomb.[46] On closer consideration, the matter appears to be more
complicated than it seems at face value. If one considers the iconographic
programmes of elite tombs as closed archaeological entities, then, after the
closing[47] of the construction and decoration activities, all kinds of factors (for
example complete or partial demolition, or factors not detected by us) have
meant that our data set is full of gaps. In short, it is indeed a random sample of
what once existed, because the named factors may or may not have been active
in a completely indiscriminate way. An Egyptologist can choose consciously
for the iconography of the "scenes of daily life" or rather "secular scenes"
from this given but incomplete iconographic total. Then, one studies a *select*
sub-set/population, which, however, because of the present lacunae (resulting
from the named factors), still has a *random* character in respect of *all* once
existing "secular scenes".

In other words: the *total* material studied by us is a sample of which random-
ness is determined by factors that have been active both outside of us *and* of
the original tomb owners. From this sample one may collect all "secular
scenes", of which, subsequently, one may study statistically all specific (sub)-
themes and/or attributes of (sub)-themes and/or combinations of those. From

[44] See for these concepts Fletcher, Lock, *Digging numbers*, 9-11; Shennan, *Quantifying archaeology*, 48ff.

[45] Even if it were possible to transport the researcher to the Old Kingdom, he would still be dealing with a partial population for two reasons. Firstly: should he end up in the 5th dynasty, his material would be incomplete, because the last elite tomb still had to be built. Secondly: were he present at the building of the last elite tomb, his material would be still incomplete, because at that moment an unknown number of tombs (for instance that of the "Two Brothers", cf. Moussa, Altenmüller, *Grab*, 13ff.) would already have been at least inaccessible, if not demolished. Buch-berger, *Transformation*, 12-13, 32 also acknowledges the necessary incompleteness of our data and its consequences, cf. also below p. 60.

[46] For these and other sample techniques, cf. Fletcher, Lock, *Digging numbers*, 63-67; Shennan, *Quantifying archaeology*, 373-390.

[47] *Nota bene*: not necessarily after the "finishing", since all kinds of factors may have pre-vented a proper completion of an elite tomb, for instance, the owner's (premature) death or fall from grace. For the prevention of this latter, very unpredictable and threatening fate, at the begin-ning of a career, see *LÄ*, II, 48-481, s.v. "Gefährdungsbewußtsein".

the foregoing, it will be obvious that *deductive* conclusions can be drawn from these collections of material in as far as they are investigated as complete populations *within* their own frame(s) of reference (for example, concerning all *preserved* milking scenes), but *inductive* ones in as far as they are analysed as random samples *outside* their frames of reference (for example, concerning all *once* extant milking scenes). This answers the question on the statistical approach on the preceding page, viz. that, depending on the researcher's starting point, both may be applicable.

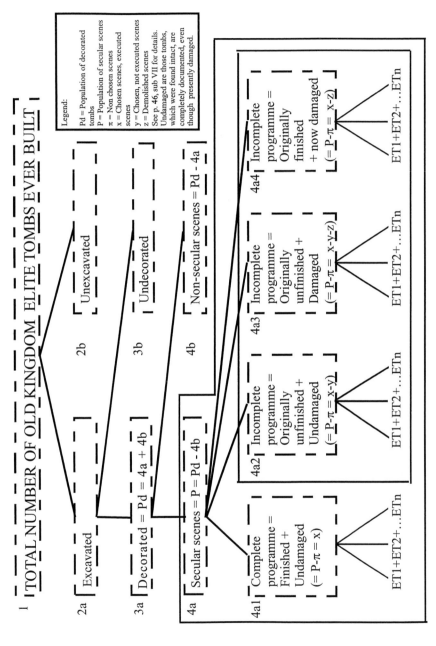

Scheme A. Population structure of Old Kingdom elite tombs

3.2.4.2. Population Structure of Old Kingdom Elite Tombs

In order to visualize the more abstract exposé of the previous pages, the line of argumentation is illustrated in scheme A with some explanatory commentary.

I Exact size of the original population (1) is unknown and will remain so until sub-population 2b no longer exists.

II Sub-population 2a is a random sample from 1. From this level, the exact numbers of all sub-populations can be established.

III Sub-populations 3a-b are *in general* random samples from 2a, but in the *specific framework* of the Leiden Mastaba Project they are non-random, leaving 3b by definition out of consideration.

IV Sub-population 4a forms the actual material of the LMP and is therefore a non-random sample. Although scenes of offering to the (seated) tomb owner may have, strictly speaking, a (strong) ritual/cultic = "religious" or non-secular connotation, they are recorded under "secular" scenes, since the act of eating itself is profane. This makes 4b a theoretical sub-population, since deities and kings are never depicted in private tombs in the Old Kingdom, as already noted on p. 34. Therefore, 4a appears to be non-random for the Egyptians as well.

V In 4a *quantity*, as absolute number of *tombs* and as absolute number of (in)complete *iconographic programmes,* coincides. However, it should be borne in mind that the present study concerns primarily *qualitative* aspects of a sub-population consisting of individually composed (sub)-theme programmes. Even though a tomb may be undamaged, it represents a qualitative selection (and sometimes a quantitative as well when a specific (sub)-theme has been represented more than once) from all available (sub)-themes at a certain period (see scheme B (p. 52), implying (a) certain meaning(s) and purpose(s).

VI Only sub-population 4a1 gives us a *complete* non-random sample composed by the *Egyptians* from the total iconographic repertory once available. However, there are three – and therefore shown here in a separate framework – modalities of *in*completeness: 4a2-4a4. Only in the case of 4a2 do we have an exact idea of the degree of completeness/incompleteness per individual tomb. For we know which (sub)-themes have been chosen *and* executed, but we can never know the others which may originally have been chosen but not executed, absolutely irrespective of cause. In the case of 4a3, especially with severe damage, only partly preserved (sub)-themes may be identifiable, but in case of completely lost registers, it is impossible ever to establish their degree of (in)completeness at the moment of the interruption of the work. The

same holds true for case 4a4. So *we* cannot (sharply) distinguish between the latter two *now*, but for the *Egyptian* the difference was obvious *at the time*.

In summary, at the time the Egyptian could discern sharply between 4a2/4a3/4a4, while we can only do this between 4a2/(4a3+4a4). All three cases are for us random samples from the total of iconographic motifs once available. However, only case, 4a2, has *one level* of randomness for both the Egyptian *and* for us, namely the random conditions causing the interruption of the work at the time. However, cases 4a3+4a4 still have *one level* of randomness for the ancient Egyptian, namely the same as of 4a2, but *two levels* for *us*, namely the original conditions of interruption *plus* the random conditions of the (partial) demolition over the ages.

VII Since sub-population 3a equals the total population (*Pd*) of iconographic (sub)-themes and elements once available for elite tombs, the situation for 3a-4a4 can also be presented in a formal manner:

$3a = Pd = 4a+4b$,

$4a = P = Pd-4b$,

$4b = Pd-4a$,

$4a1 = P-\pi = x$, where π is the number of (sub)-themes/elements (= sub-population) *not chosen*; x is the number of (sub)-themes/elements *chosen and executed* per individual tomb,

$4a2 = x-y$, where x is the number of (sub)-themes/elements *chosen and executed* and y is the number of (sub)-themes/elements *chosen* but *not executed* per individual tomb,

$4a3 = x-y-z$, where x is the number of (sub)-themes/elements *chosen and executed*; y is the number of (sub)-themes/elements *chosen* but *not executed* and z represents the demolished, originally executed (sub)-themes in the wall areas of x per individual tomb,

$4a4 = x-z$, where x is the number of (sub)-themes/elements *chosen and executed* and z represents the demolished, originally executed (sub)-themes of x per individual tomb.

VIII The exact number of *Pd* that *Egyptology* is able to establish is the sum of all the different (sub)-themes and elements found in the individual tombs = iconographic programmes of the Old Kingdom. The *original*, exact number at the end of the Old Kingdom will never be reconstructed – even after sub-population 2b has been neutralized – because of y and z which may once have consisted of a number of (sub)-themes and elements that by mere chance have been completely wiped out by subsequent demolition.

The main statistical principles[48] for the analysis of the iconographical material having been clarified, and before starting to process the latter, it is essential to pay closer attention to our own *position* with regard to the ancient Egyptian culture in relation to our approach of the visual data available at a semantic level.

[48] Understanding of the statistical *principles* inherent to the material to be studied is more important in the present context than a detailed discussion about statistical *procedures*. The present author fully subscribes to the opinion of Adams, Adams, *Typology*, as in the quoted mottoes on p. 40. To this can be added p. 292: "A second important consideration is that statistical tests do not reveal the *causes* of non-randomness, the reasons why certain clusters of attributes regularly occur together..." and thus "So far..., we would conclude with the general observation that while statistical *principles* are important, statistical *procedures* usually are not" [or more subtly formulated: *less*, RvW].

3.2.5. *"Emic" / "Etic"*

A correct interpretation of one culture purveyor by another depends on an understanding of the polar adjectives *emic* and *etic* used, for instance, in archaeology, psychology and anthropology.[49] They are borrowed from linguistics where speech sounds are studied in two ways: as phon*etics*, that is as purely physiological products of the human voice and independent of a language, and as phon*emics*, which are characteristic of a specific language and, hence, possess a semantic charge valid for that language. An emic approach, therefore, is a study from the culture system itself, using internal criteria and concepts, while an etic one is from the outside via external criteria and general concepts. This point, in fact, is the core of the argument, very well worth considering, in Weeks' *Art*, where the iconography of elite tombs is central, although he does not use these specific terms. A word of caution, it is essential to remain critical about the *degree* to which a, by nature, external study may coincide with an inside view on reality/existence.[50]

[49] Adams, Adams, *Typology* with differences in nuances, pays much attention to these concepts with respect to classification, see their index 416, s.v. "emic" and "etic"; cf. also Matsumoto, *Culture and Psychology*, 35-37. As far as I know, Faltings, *Keramik*, 290, is the only study on elite tomb iconography that uses these concepts explicitly. Bolshakov, *Double*, 15-17, also considers the problem, but like Weeks, *Art* does not use these terms.

[50] See for this critical attitude Versnel, *Reflections*, 184-185 with notes 24-27 and Matsumoto, *Culture and Psychology*, 122.

Nowadays, of course, we don't believe a word of it.
Or at least we don't believe a word of our version of their beliefs…
The vision of the Fourth Dynasty is as irretrievable as the vision of
one's own childhood.

P. Lively, *Moon Tiger*, 114-115

The archaeologist stands vulnerable and exposed,
strategist in the conceptual struggle for a meaningful past.

Shanks, Tilly, *Re-constructing Archaeology*, 28

3.2.6. Selection and Existence

The iconographic programme of an elite tomb confronts us with (a part of) the reality as the ancient Egyptian experienced it (his "input"), dealt with it (his "processing"), and expressed it in representations and texts (his "output").[51] On closer consideration of the output, it appears that he did not record everything pertaining to his reality. For instance, in pyramid temples and/or elite tombs human beings were never represented while hunting crocodiles[52] (cf. p. 46, VIII, end for its once theoretical presence), in contrast to scenes of fowling, fishing and the hunt for hippopotamuses. Therefore, the Egyptian made a selection from the existence he experienced.

The foregoing reveals that, should one have the – mistaken (cf. p. 42) – impression that both the ancient Egyptians and we faced, respectively face, *ancient Egyptian* reality via a *random* sample,[53] one overlooks that this is only valid for *us*. Only a tomb owner who had, chosen literally blindfold the iconographic (sub)-themes from a model book – if they existed[54] – would end up with a non-selective "sample" from all existing *(sub)-themes* (selected by the *composer(s)* of the book), not from *reality*. Cogently it is an absurd assumption, that an Egyptian would play such a "game" with the decoration of such an important monument as a tomb. Therefore, the conclusion has to be that, from the Egyptian perspective, a decoration programme of an elite tomb was a highly selective composition from once available (sub)-themes, dependent on, among other things, chronological factors and access to certain ateliers, because not all workshops necessarily had the same repertory available. The foregoing is illustrated by scheme B of the "structure of iconographic selection process".

[51] The terms between "" are borrowed from cybernetics or general systems theory which, from certain angles of approach, provides a useful model and set of concepts for the analysis and description of processes and mechanisms which are active in a culture, see Renfrew, Bahn, *Archaeology*, 421-422. For a more extensive discussion of the various (problematic) aspects by Chapman, since it was introduced in archaeology by Clarke, see Clarke, *Archaeology*, 142 (n. 4)-148.

[52] It is very remarkable indeed that there is not a single example of a violent confrontation between man and crocodile, but exclusively between crocodile and hippopotamus (for instance, Harpur, *Decoration*, fig. 189, pl. 23), where the former is always defeated. An explanation that the crocodile would be less harmful or dangerous to man than to hippopotamuses (o.c., fig. 190: a half-born hippopotamus is threatened by a crocodile) is belied not only by a fish-eating crocodile (o.c., fig. 192) damaging man's subsistence level, but even more by the scene in Ankhmahor's tomb, where a fording cowherd is menacingly flanked by crocodiles, while a long spell to avert this was added above (p. 82, fig. 15). See further, p. 89.

[53] As further expounded in a different context on p. 63, it is of essential importance to a correct understanding to realize that both the ancient Egyptian and we reacted, respectively react, to the "objective" or external reality by means of sampling (cf. p. 25-26) and that this happened, respectively happens *selectively*. However, the results are (most of the time) radically different, showing a sharp difference between the ancient Egyptian and our *interpretation* of existence and its resulting mentality. This difference pervades and shapes the entire cultural system to such an extent that it is impossible to take an(y) artefact of our culture (except for modern Western replicas of Egyptian artefacts) for an ancient Egyptian and vice versa.

[54] For the highly disputed existence of model books, cf. Kessler, *Bedeutung*, 61 with n. 11 and more recently Faltings, *Keramik*, 288-289 and Herb, *Wettkampf*, especially 243-252, 289-290, 301-303, for further references see his index s.v. "Musterbuch", "Vorlage".

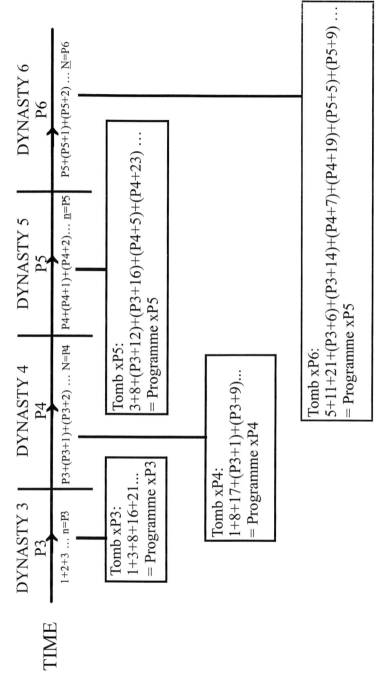

Scheme B. Structure of the selection process of
iconographic (sub)–theme programmes in individual tombs.

N.B. P_3, P_4, P_5, and P_6 represent the iconographic sub-populations at the *end* of
each dynasty 3-6. An individual tomb, x, = individual iconographic programme, represents a sub-sub-population of these: $^1P_3+^2P_3+...^nP_3 = P_3$;
idem for P_4, P_5, and P_6. P is the total sum of these at the end of dynasty 6, which equals P (= sub-population 3a) of scheme A (p. 43)

The following aspects deserve to be paid closer attention.

I. This scheme continues scheme A, bottom, at the level of the individual tomb programmes. It is obvious that of the individual tombs xP3-xP6, taken as examples, each can never contain more *chosen* (sub)-themes than those found left of the connection line with the line of the arrow of time. In theory, they might contain all (sub)-themes in this area, but in practice they only show an *individual selection* from what is actually available which is proved by the fact that no two programmes are completely identical.[55] New (sub)-themes may be added to the available stock, which increases the margins of choice for the later individual programmes.

II. One should realize that the tomb owner was not absolutely free in his choice that was determined by both *qualitative* and *quantitative* factors.

The *qualitative* factor concerns the *content* of the programme and consists of:

1. *indispensable* (sub)-themes = *no freedom* of choice concerning content, for instance: (a) representation(s) of the tomb owner (standing, or seated behind an offering table), displays of offerings, offering bearers.[56]
2. *dispensable* (sub)-themes) = *freedom* of choice concerning content, for instance: the building of ships, scenes of music and dance, of fish processing, fording of cattle, children's games and the like.

The *quantitative* factor, that is the available *wall surface*, may have been potentially, though not necessarily, contributory to 1 and 2 in four ways:

a. with regard to the iconographic *size* of 1+2: much space –> large representations of (sub)-themes.
b. with regard to the iconographic *width of variation* of 2[57]: much space –> many "free" (sub)-themes; thus Ti's tomb (5th dynasty) contains the so far known greatest variety of (sub)-themes combined in a single iconographic programme.
c. with regard to the iconographic *design* of 1+2: much space –> many added and/or repeated elements/motifs/details in 1,[58] or, in case of a small width of variety of 2, for instance (very) extended series of music and dancing groups, scenes of fishing with a seine or of fording scenes and the like.[59]

[55] Not even the tomb of Nesutnefer at Giza p. 54, fig. 5 is an exact "copy" of its neighbour, Seshathetep's. Cf. Herb, *Wettkampf*, 242 with n. 315 and his index s.v. "Kopie" and my *Individuality*.

[56] Indispensable scenes are those that occur in *all* iconographic programmes during the *entire* period of the Old Kingdom, or from a *certain moment* to which the research is related. All others are dispensable or optional, cf. below, main text, p. 60. The indispensable examples are also mentioned in Assmann, *Hierotaxis*, 38, who also extensively discusses the compositional "rules" limiting the tomb owner's/artist's freedom. For a recent (not always convincing) application and elaboration of Assmann's rules, see Fischer-Elfert, *Hierotaxis*.

[57] Not of 1, because, independently of whether there was much or little space, the indispensable (sub)-themes, such as the owner standing, or seated (behind an offering table) will be included at least once, cf. Harpur, *Decoration*, figs. 2, 4, 8-10, 14 etc.

[58] For instance, repetition of the complete motifs of n. 57, or a larger number of loaves on the offering table, or a greater variety and/or repetition of offerings displayed.

[59] For fishing, cf. Harpur, *Decoration*, figs. 85-86 (compact design) with fig. 89 (very much extended) and our fig. 9 (p. 59) and 10 (p. 60). For the more correct term "seine" for the often

d. with regard to a *combination* of both b+c may appear in 2: much space –>
both a greater width of variation *and* a(n) (more) extended version(s) of
(certain) (sub)-themes.

III. So, the quantitative size of 1 and the qualitative *and* quantitative of
2 are determined both separately and jointly by the available wall surface.
Together, 1 and 2 are expressed in the structure of selection of the icono-
graphic sub-population "secular scenes" (see schemes A, 4a, and B). This
implies that the configuration of 1-2 actually depends directly on a "higher"
and chronologically preceding decision, which fixed the extent, related to
ground-plan, of the space available for decoration. The architecture must be
there, before the execution of the iconographic programmes can commence
(figs. 5-8).[60] Indubitably the iconographic population under discussion consists
of intentionally and individually conceived decoration programmes which are
composed on the basis and as results of different and complex factors of partly
material (status/wealth of the owner) and partly immaterial (value and mean-
ing attached by the owner) character.

Fig. 5. Plan of the tomb of Nesutnefer, Giza.

used term "dragnet", cf Brewer, Friedman, *Fish*, 42-46. For fording, cf. Harpur, o.c., figs. 120-
122 (compact design) with fig. 211 (= our fig. 15, very much extended).

[60] Fitzenreiter, *Grabdekoration*, 94-111 and Herb, *Wettkampf*, 41 with n. 68, recognize the
importance of the architecture in relation to decoration, but without considering the present
aspects.

Fig. 6. Plan of the tomb of Kaiewedja, Giza.

IV. Ideally, our data (= statistical material) should be a complete set (= popula-
tion) of all (sub)-themes of the iconographic programmes ever conceived for and
realized in the elite tombs of the Old Kingdom in the Memphite area. On this
assumption one might draw statistically very reliable conclusions about various
questions.[61] For instance, it would be possible to establish in absolute numbers,
how frequently which (sub)-theme was chosen on which wall (= orientation), and
where (= wall (com)position). Actually, one would have the complete picture of
each programme as composed by the tomb owner himself.

Two factors prevent this:
1. the decoration is incomplete (the "indispensable" (sub)-themes will suffer
 the least from this, since they were probably executed first);
2. the decoration was partly destroyed:
 2a. (partly) reconstructable/identifiable,
 2b. definitively lost.

Although their absence may be the outcome of completely different causes,[62]
we have concluded on p. 46, VIII that it will never be known which (sub)-
themes were chosen in the case of 1, but not executed, and which, in the case
of 2, were both chosen and executed but have been definitively lost to us,
through which again the – only for *us* – non-selective character of the data set
emerges.[63]

[61] Cf. Van Walsem, *Mastaba Project*, 143-145.
[62] See p. 42 with n. 47.
[63] See pp. 42 and 51.

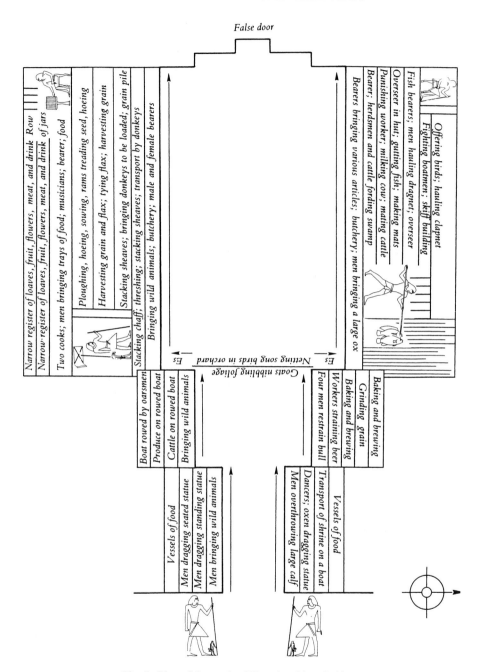

Fig. 7. Plan of the tomb of Hetepherakhty, Leiden.

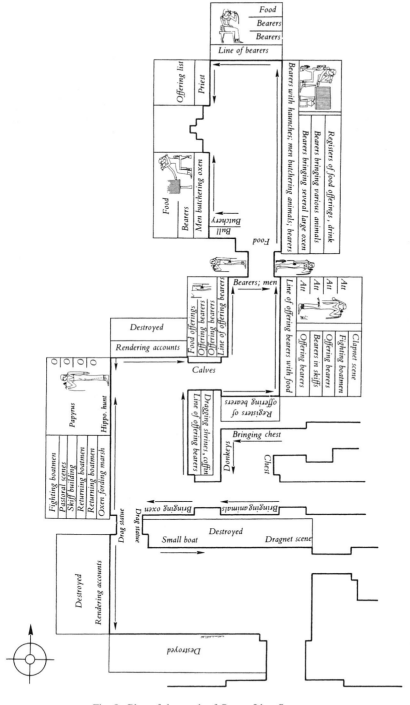

Fig. 8. Plan of the tomb of Queen Idut, Saqqara.

V. Summarizing, one may conclude from II and III that the relative *freedom of choice*, consciously applied by the owner, represents *the* outstanding factor in our incomplete perception of the iconographic repertory (once) available from which the individual programmes per tomb were realized, rather than the (originally) unintentional and accidental abortion of the execution of the programme and/or its subsequent (partial) destruction.

This is especially clear in the case of the last factor, when, above a complete register on a (very) long wall, another register has been completely demolished with the exception of some barely identifiable remains in the middle. In such a case it will remain impossible to establish whether the owner had originally chosen different, "short" flanking (sub)-themes, or had "stretched" a single (sub)-theme along (a large part of) the entire register. Compare, for instance, the scenes of fishing with a seine in the early 4th dynasty (very short: Rahotep, fig. 9, p. 59) and the 6th dynasty (very long: Mereruka, fig. 10, p. 60): the same sub-theme (from the main theme "fishing"), but elaborated differently, mainly because of the larger wall surface (cf. above p. 53, II,c).[64]

In other words, every programme which is for us virtually always incomplete[65] primarily teaches us something about the owner's preferences, while the "rules"[66] applied vary with each individual.

So, as stated on p. 46 VIII where it is phrased slightly differently, Egyptologists reconstruct the sum of all (sub)-themes that were originally available from the different sets of choices once composed into individual iconographic programmes. In their turn, the frequencies of the individual (sub)-themes indicate the *degree of importance* attached to them by the tomb owner. Linking this importance to chronology reveals a funerary "iconographic fashion" as the exponent of a certain *mentality* (cf. p. 14 and 86) touching upon funerary matters. In its turn, the iconographic content shows which *"segments" of this mentality* and/or "Weltanschauung" the researcher is dealing with. However, because of the (relative) freedom of the Egyptian, in other words because of the virtually unpredictable composition of an iconographic programme, one will never be able reliably to supplement, respectively reconstruct the preserved statistical population to its original size. There is no option but to depart from the data only available.[67]

Therefore, bearing in mind these conclusions, it is I believe legitimate to make statistically relevant statements on the basis of even small numbers,

[64] Of course, one should realize that the general chronological trend in the development of this scene is an increase in complexity, reflecting a different "mentality" expressing a need of more "realistic" representation of this method of fishing. It is obvious that the older variation where three adults are needed to drag in only three fishes is a kind of *pars pro toto* for a sizeable *group* of fishermen, hauling in *many* fishes.

[65] The Leiden mastaba, for instance, is an exception: although there is a damaged area on the south wall, all (sub)-themes are identifiable.

[66] See too below, p. 67ff., 85 and 93 and the mottoes on pp. 66, 84 and 92.

[67] Buchberger, *Transformation*, 32 also notices this problem, cf. also above p. 42 with n. 45.

Fig. 9. Wall in the tomb of Rahotep, Meidum.

although one has to indicate *which degree of* probability these statements contain, and one must be constantly conscious of the fact that what is concerned is a *degree* of probability only.[68] The Egyptians themselves are highly cooperative in this respect, as can be demonstrated in the following survey of the various possibilities for the absence/presence of a (sub)-theme per individual tomb.

[68] Cf. idem, o.c., 19. Bolshakov, *Double*, 48, also recognizes the problems of limited statistical data, but does not discuss the degree of probability.

Fig. 10. Part of a wall in the tomb of Mereruka, Saqqara.

Fig. 11. Wall in the tomb of Neferirtenef, Brussels.

ACTUAL OBSERVATION			CAUSES OF OBSERVATION
iconographic	programme	scene	
A *un*damaged	finished	+	consciously present (= (in)dispensable)[69]
B ,,	,,	-	,, absent (= dispensable)
C ,,	*un*finished	+	consciously present (= (in)dispensable)
D ,,	,,	-	1. consciously absent (= dispensable), or 2. "chance" (= (in)dispensable)
E damaged	incomplete	+	consciously present (= (in)dispensable)
F ,,	,,	-	1. consciously absent (= dispensable), or 2. "chance" (= (in)dispensable)[70]

[69] Absolute indispensability can only be ascertained by analysis of a complete (sub)-population, cf. n. 56.

[70] The differentiation of "undamaged", respectively "damaged", between C-D and E-F is of more than mere theoretical importance. Although in *both* cases we have an incomplete programme

The preceding analysis of the various aspects connected with the structure of iconographic selection demonstrates that every programme – even though a number of (sub)-themes occurs rather frequently – has a highly selective character originating from the tomb owner. This personal selection concerns four levels:

a. deciding which main theme(s) among the total number of main themes will be incorporated, for instance, "agriculture", "cattle-breeding", "fowling", "marsh scenes", "trades", while excluding others, such as "ships", "kitchen scenes".

b. choosing which sub-theme(s) of the main theme(s), for instance, tree-net, feeding, caging of the main theme "fowling" should be executed.

c. deciding the size of the sub-theme: compact versus extensive.

d. deciding the absence/presence of certain noteworthy attributes, such as the wearing of sandals.[71]

It is obvious that these decisions depended primarily on psychological reasons, which were known only to the tomb owner than on the presence of material means. Now, the basis of any selection is the tendency to make something *manageable* or *demonstrable* in a complex reality by using classification (in the widest sense of the word) along either (partly) conscious or unconscious sets of "rules". This brings us back to the central importance of classification and statistics, pointed out on pp. 25-26, 41-43. The phenomenon of a complex system manifesting itself via an in- and output, while the observer himself is unacquainted with the system, that is what is inside and how it operates, is called a "black box"[72], that is an incompletely observable system, again using a term borrowed from general systems theory.[73] The task of the Egyptologist is to establish the components or sub-systems of the system and its regulators, in short its "mechanics".

The ancient Egyptian elite tomb is such a system, or rather a sub-system of the overall Egyptian culture system. An investigator selects a number of attributes or features and via an analysis tries to discover regularities that will enable him to formulate a working hypothesis or even a covering theory about the meaning of the elite tomb: induction as mentioned earlier.[74] The conclusion, for instance, is that it concerns a tomb whose decoration serves the deceased's

at our disposal, *we* are able to calculate the percentage of the *un*damaged tombs that were already *certainly* unfinished and consequently incomplete at the time of the owner's demise. On this basis, one could (very tentatively) estimate the number of E-F that might, originally, be counted as belonging to C-D.

[71] Cf. Siebels, *Sandals*, esp. p. 87: "The decision to wear sandals appears to be simply a matter of personal choice…" Fitzenreiter, *Grabdekoration*, e.g., 73-75, 92, correctly stresses the individual aspects as well.

[72] Cf. Clarke, *Archaeology*, 58-62.

[73] Cf. p. 51, n. 51.

[74] See p. 25, 42-43.

well-being in the Hereafter. The next step is to say something about the Egyptian realm of thought in general, for instance, that the Egyptians imagined the Hereafter as (almost completely) identical to earthly existence. The researcher takes this step because of the "fact" that, he argues, the "deceased" who is in the Hereafter is represented observing secular scenes: more induction, the more so since not a single contemporaneous text confirms this unambiguously. The statement is apparently based on the implicit supposition that, for the Egyptians that is, the (standard) space and time scale of the deceased owner (who was buried on the spot), that is his post mortem existence, were identical to his representation as a standing or sitting living being in the tomb iconography. [75] There is a rub as, in my opinion, it is wrong to say that "the deceased" is represented. A really deceased person, namely as a mummy or corpse lying on its back, has *never* been represented in any Old Kingdom elite tomb, but always the living owner with his living relatives and subordinates.[76] It is utterly irrelevant here that, of course, ultimately he died. It is our (supposedly scientific) use of language that should be adjusted or rather corrected by using the term 'tomb owner' which is neutral with respect to his biological existential situation. The few examples of the Middle and New Kingdom of n. 76, as well as the standard New Kingdom scenes of the living tomb owner in the presence of the gods, of course, represent an impressive change of mentality, utterly absent in the Old Kingdom.

Statements are not very reliable if based solely on one elite tomb. Conscient of this, the researcher includes more tombs and material outside his starting point, in other words, he extends his sample. The extra data will enable him to find other and more sophisticated regularities in the meantime less hidden "black box" than before.[77] In short, he is trying to find and interpret the rules and related categories of the past system by means of regularities or patterns which result from his (that is in first instance "etic"[78]) classifications of attributes. This is the hermeneutic spiral or more appositely, cone.[79]

[75] Cf. Sørensen, *Access*, 112-113. This issue was also commented upon by Bolshakov, *Double*, 194, also stressing that it is our interpretation.

[76] See for this matter Kanawati, *Living*, esp. 223-225. For the 11th dynasty example of Djar's mummy, see Vandersleyen, *Ägypten*, pl. 266, and for the New Kingdom examples of the deceased Maketaton and Dhutymose, Brunner Traut, *Ägypter*, fig. 4 and 59a.

[77] Cf. again Buchberger, *Transformation*, 19 and 31-32 on this procedure regarding other material.

[78] Cf. p. 49.

[79] In the words of Shanks and Tilly, *Re-constructing Archaeology*, 104: "We can suggest that any interpretative account of the past moves within a circle, perhaps more accurately, a widening spiral, and involves changing or working theoretically upon that which is to be interpreted". A circle and a spiral as described here remain in the same two-dimensional plane. Therefore I think it better to use the image of a spiralling *cone*, which incorporates the dimension of time which is necessarily involved in any development of interpretation. The cone's apex represents the scholar's point of departure, asking the first research question in his field; the end of the line represents his death. All individual cones form the collective, i.e. intersubjective, "cone of knowledge/interpretation" concerning (the segment(s) of) reality/existence, covered by the scientific field or discipline.

Here it is essential to stress that the *out*put of the Egyptian, for as far as it has been preserved, is *in*put for the Egyptologist. Consequently it becomes and is a part of *his* integral, experienced reality/existence. This too he makes manageable via classification. Still, this ancient Egyptian segment is so complex that he, in his turn, too can or rather must select only a limited number of attributes (= data)[80], which he *thinks* that they may result for *his* fellow men in statements (= his *out*put) about the ancient Egyptians and their experience of reality which are methodologically verifiable and reliable (namely according to the rules of his scientific practice, his internal processing, which is based on Western logic).[81] The accuracy of our understanding of the ancient Egyptians is proportional to the measure of correspondence between both outputs. It stands to reason that complete correspondence is impossible. The closest fulfilment of this aim could be only realized if the researcher lived at the same time and in the same place. Even then it would be but partial, simply because it is physically impossible for a culture purveyor to grasp even his own culture entirely.[82] Given this, by nature a scholar's position in relation to grasping and understanding a different culture is rather weak and complex. The archaeologist is in the worst position because he encompasses all four levels of hermeneutics, as summed up by Shanks and Tilly, which are best quoted literally (italics are mine):

"(i) The hermeneutic of working within the *contemporary discipline of archaeology*;

(ii) The hermeneutic of *living within contemporary society* as an *active participant*,....;

(iii) The hermeneutic of trying to understand an *alien culture* involving meaning frames radically different from his or her own;

(iv) The hermeneutic involved in *transcending past and present.*[83]

The preceding discussion of the position with respect of reality/existence and its ensuing selection procedures of both the ancient Egyptian and the modern Egyptologist is visualized in scheme C below.

[80] Buchberger, *Transformation*, 19 puts this state of affairs brilliantly into focus in his quotation from M. Schatzmann, *Die Angst vor dem Vater* (Reinbek bei Hamburg, 1978), 96: "Selbstverständlich isoliert jeder Wissenschaftler bei seiner Arbeit nur einen, zumeist nur winzigen Bruchteil des Gegebenen als Daten. Was wir normalerweise Daten, das heißt das Gegebene, nennen, sollte vielleicht besser 'Capta', das heißt das Genommene, heißen."

[81] Very instructive on these matters are Shanks, Tilly, *Re-constructing Archaeology*, 7-28, esp. pp. 7, 14, 17, 22, 23 ("That which is analysed becomes part of the archaeologist's life, his or her experiences of doing archaeology"); cf. also Zubrow, *Knowledge*, 107 and Peatfield, *Cognitive Aspects*, 149-150 ("Consequently, all interpretations are expressed in the terminology of the ideology shared by the individual scholar's preferred peer group"). Cf. also p. 69.

[82] Witness the sub-division of a social science, for instance, history into: political, social, economic, art history, and so forth, which essentially exclude each other but, of course, share overlapping areas.

[83] Shanks, Tilly, *Re-constructing Archaeology*, 107-108. Although in Hodder, Shanks et al., *Interpreting Archaeology*, 10, this fourfold hermeneutics is again reduced to a twofold, the above series reveals better the subtleties involved.

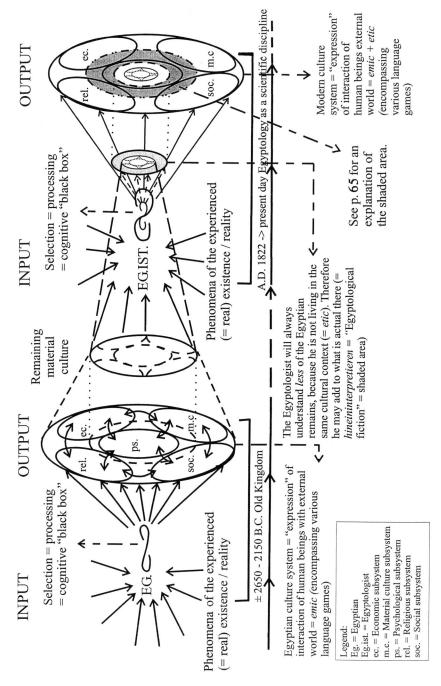

INPUT

OUTPUT

Selection = processing = cognitive "black box"

Phenomena of the experienced (= real) existence / reality

± 2650 - 2150 B.C. Old Kingdom

Egyptian culture system = "expression" of interaction of human beings with external world = *emic* (encompassing various language games)

INPUT

Remaining material culture

Selection = processing = cognitive "black box"

Phenomena of the experienced (= real) existence / reality

A.D. 1822 -> present day Egyptology as a scientific discipline

The Egyptologist will always understand *less* of the Egyptian remains, because he is not living in the same cultural context (= *etic*). Therefore he may add to what is actual there (= *hineininterpretieren* = "Egyptological fiction" = shaded area)

OUTPUT

See p. **65** for an explanation of the shaded area.

Modern culture system = "expression" of interaction of human beings external world = *emic* + *etic* (encompassing various language games)

Legend:
Eg. = Egyptian
Eg.ist. = Egyptologist
ec. = Economic subsystem
m.c. = Material culture subsystem
ps. = Psychological subsystem
rel. = Religious subsystem
soc. = Social subsystem

Scheme C. Selection and interaction procedures of the ancient Egyptian and the Egyptologist with regard to reality.

The next note concerns the shaded area on the far right and could not be included in the diagram:

Although the ancient Egyptian component of a modern Egyptologist's and laymen's reality in their culture system is primarily an element of their *psychological* sub-system (one *feels* attracted by the ancient culture without being able to exactly formulate why and so forth), it may very well "radiate" onto the other sub-systems (shaded area): by studying ancient Egyptian religion one's own religious outlook (if one has one) may be influenced, for example by relativization of "truths of faith"; Egyptology is not an economically affluent discipline; socially an Egyptologist may be respected or despised for his "non-standard" activities, and in his material cultural milieu there may be more than an average number of references to ancient Egypt.

In short, as a consequence of scheme C, we should be modest about the potential import, depth and accuracy of our conclusions and interpretations. The following quotation makes this point exactly: "It concerns *forms* of life and thought whose description has been attempted here. Approaching the essential *content* which has rested in these forms, – will it ever be the work of historical investigations?" This is the last sentence of Huizinga's introduction to his *Waning of the Middle Ages*.[84]

Note, Huizinga speaks only of "describing"; "interpreting" he circumscribes as "Approaching the essential content". Apparently, at the time, he thought it was an open question, a question which Panofsky, almost twenty years later, believed himself able to answer positively by means of his iconological method. His neglect, as noted on p. 22, of important epistemological aspects of his method made this chapter necessary. Its essential and inevitable conclusion is that both our scientific practice and the subsequent results necessarily contain a varying amount of subjectivity. Again, necessarily, it will always entail partial and easily contradictory conclusions and interpretations, in other words: pluralism. The next chapter will deal with the question of whether a model is conceivable that will best be able to accommodate *both* the ancient and modern pluralisms.

[84] The translation is mine, after the 20th edition of Huizinga, *Herfsttij*, viii. The introduction is the one of the first (1919) edition, which has been adapted in the later English translations (since 1924) where this sentence was omitted. The italics are original.

…Ist nicht mein Wissen, mein Begriff vom Spiel, ganz in den Erklärungen ausgedrückt, die ich geben könnte?…

…Isn't my knowledge, my concept of a game, completely expressed in the explanations that I could give?…

Wittgenstein, Philosophische Untersuchungen, 75

Nicht um die Erklärung eines Sprachspiels durch unsere Erlebnisse handelt sich's, sondern um die Feststellung eines Sprachspiels.

The question is not one of explaining a language-game by means of our experiences, but of noting a language-game.

Idem, 655

…Und gibt es nicht auch den Fall, wo wir spielen und – 'make up the rules as we go along'? Ja auch den, in welchem wir sie abändern – as we go along.

…And is there not also the case where we play and – make up the rules as we go along? And there is even one where we alter them – as we go along.

Idem, 83

4. PLURALISM

4.1. LANGUAGE-GAMES

The preceding exposé may be summarized as one of the central problems of Egyptology as follows: the ancient Egyptian had to deal with only *one* input in his/her own (cultural) reality; the Egyptologist sets himself the aim or rather task (cf. p. 1-4), leaving aside his own (cultural) reality, to come to grips with another, namely that of ancient Egypt. In doing so he has to base himself on data which are full of gaps.

This inexorably implies that what one tries to grasp as "reality" beyond the remaining data of the ancient Egyptian culture, is always *our* construction, determined and modified by a, by definition, etic point of view, borrowed from our own context.[1]

Admittedly such a construction can only be made in language, but in a language that operates by various (systems of) rules: in the twentieth century one can speak about the ancient Egyptian culture as part of one's own reality in scientific, esoteric or romantic terms, dependent on one's point of departure and aim.[2] Although in all three cases many formally identical words will be used, their meaning will differ in response to different rules. The ancient Egyptian, too, could do this for *his* reality. Therefore, earlier I called (p. 41, speaking about the lack of regularity in the social sciences) human free will literally the killjoy, while almost simultaneously[3] it is a "key player" or rather "game maker": by breaking and/or changing the rules it starts another "game".

Here, the great merit of Wittgenstein's philosophy, as expounded in his posthumously published *Philosophische Untersuchungen* (1953), is that it points out that man is only able to speak about his external reality via different "language-games", each with its own set(s) of rules, starting-point(s), aim(s) and context.[4]

[1] Cf. Peatfield, *Cognitive aspects*, 151. In contrast to what is often, if not mostly, said about archaeology and/or cultural history, namely that the *re*construction of cultural reality should be the main aim, it is only possible (literally) to reconstruct *artefacts*. All our articulations concerning a past cultural reality within which they are supposed to have functioned are, strictly speaking, *con*structions about a reality which can never be experienced again. See especially Shanks, Tilley, *Re-constructing Archaeology*, xvii-xviii, 16, 98, 105-107, 111, 247ff., esp. 257.

[2] Cf. Van Walsem, *Iconographic Programmes*, 1211 for a practical, but fictitious example.

[3] For the subtleties involving the word "simultaneous", cf. Van Walsem, *Chaos*, 320-323.

[4] Wittgenstein, *Philosophische Untersuchungen*, 66-67 explains his use of the word "game", by pointing out that the categories of activities covered by this term all have certain rules and/or features in common, but there is no *single* feature/rule in common to all. This is similar to individuals in a family. Therefore, games have only what Wittgenstein calls "family resemblances". Kemp, in *Ancient Egypt*, uses the term "language-game" as well (cf. index, 352) without indicating whether he derives it from Wittgenstein or not.

This leads us back to his earlier statement, quoted on p. 30-31. The conclusion has to be that there are different "truths" or rather "aspects of truth" concerning one "objective" reality, depending on the (un)consciously used language-game(s), of which each single game is insufficient, or rather incomplete, to cover the entire existence.[5]

Therefore, every individual and, viewed collectively, every culture deals with reality by means of various language-games. They can be roughly divided into, for example, a scientific, religious,[6] material-cultural, economic, and social language-games, all anchored in the central cognitive psychological one.[7] They are interconnected and partly overlapping, so not strictly separated, and can be hierarchically subdivided into more specific ones almost endlessly, the lowest level being a single statement.[8] Of course, *mutatis mutandis*, this is also valid for art, in particular for iconography, which may be considered as describing a "picture/image language-game".[9] Naturally, the rules and starting-points differ per culture, if only for different geophysical and/or time dimensions.

Having been formulated in the preceding, the core of my argument follows: the working hypothesis that, in view of the complexity of existence and the complexity of location, architecture, iconography and texts, (at least segments of) different language-games are potentially simultaneously present in an elite tomb. The ancient Egyptian could interpret these directly, sometimes even contradictory,[10] segments coherently, separately or alternatingly without too

[5] For an excellent discussion of the (in)completeness of language-games, see McGinn, *Wittgenstein*, ch. 2, esp. 43-52, and 49-50; for Dutch readers, ch. 1 of Oosten, *Magic and Reason* is recommended.

[6] One should realize that science and religion were not or were hardly separated in ancient civilizations; cf. the quotation from Englund on p. 29 n. 20. The existing separation in our own culture originates from the Renaissance and is therefore a fairly recent one as well. It is interesting to discover that Newton was still convinced that the results of the (natural) sciences should be in harmony with the Bible; cf. Richardson, *Bible*, 16 (Dutch edition).

[7] The division given here is not Wittgenstein's, but corresponds to the sub-systems discerned in the culture-system model of Clarke, *Archaeology*, 84, 101-134, figs. 15, 23.

Note that the linguistic sub-system on p. 84 has been left out of the following discussions, without giving a reason. A possible, though speculative, explanation might be that Clarke considered language to fall outside the discipline of (strict) archaeology. Or, in his eyes, the linguistic and psychological sub-systems coincided in practice because language is indispensable to the human psyche after all, while the use of language is (largely) determined by the character and state of the psyche. The adjective "cognitive" has been added by me because of the recent attention paid to this aspect in archaeology, see Renfrew, Zubrow, *Ancient Mind* and Wilson, Keil, *Cognitive Sciences*, s.v. "*Cognitive Archaeology*", 122-124. The prominent importance of the written language to Egyptian archaeology has been convincingly demonstrated e.g., by Assmann, *Sprachbezug*, esp. 81-85.

[8] McGinn, *Wittgenstein*, 58, also says: "Learning our language...is essentially connected with acquiring mastery of countless kinds of language-game".

[9] See e.g., Hagberg, *Art as Language*, esp. 190, last sentence.

[10] The best example of such a contradiction, although not recorded in Old Kingdom tombs, is the "Song of the (Blind) Harper", openly casting doubt on, if not refuting, the ultimate use of

much effort, simply through his inner cultural or *emic* position, in which the artefactual messages coincided with his and his fellow men's total interpretation of their interaction with reality, their "form of life" incorporating their 'Weltanschauung' cf. p. 85-86). The Egyptologist, by nature in an *etic* position (as seen on p. 49), has to try, as much as possible by the use of a single, scientific language-game – based on Western logic[11] – not only to find out the rules of the actual or at least potentially different language-games in the elite tombs, but also to make them uniform in a straightforward way, forming them into one logical, consistent whole, implying a single *Egyptian* language-game for all scenes as well. At this point, the justifiable question arises which asks whether the Egyptians did indeed have the same in mind. This question, in my opinion, must be answered negatively,[12] witness the frequent clashes of Egyptological interpretations concerning the same material, for instance these summarized in Kessler's article *Bedeutung* (concerning the building and sailing of ships, cf. our figs. 4 and 9), Altenmüller's *Isis* (concerning the scenes of the tomb owner fowling with a throwing-stick and spearing fish, cf. our figs. 11-13), and discussed on pp. 71-72, respectively 74[13].

tombs, which are actually the only places where these songs have been recorded. The matter is complex, see *LÄ*, II, 972-982, s.v. "Harfnerlieder" and Kitchen, *Poetry*, 137-142. For a contradictory interpretation of harpist songs in Old Kingdom tombs, see Altenmüller, *Harfnerlieder* and Buchberger, *Harfnerlied*. It is interesting to note here that, in Ch. 12 of *Waning*, 148 (= 162, Dutch edition, cf. p. 65, n. 84), Huizinga mentions several cases of "avowed unbelief" of persons who, co-existing with the (very) pious majority, openly refuted the church's teachings and tenets of faith. The contradictory character of the Late Middle Ages is aptly summarized too, by Liebmann, *Ikonologie*, 312 in his discussion of Dürer's "Melencolia I" (o.c., 308, fig. 1): "Er war ein Mensch einer widersprüchlichen Epoche, in der Skepsis und fanatischer Glauben, Rationalismus und grenzenlose Träume, feste Überzeugung von den unbegrenzten Möglichkeiten, des menschlichen Verstandes und extremster Agnostizismus nebeneinander existieren".

[11] For convenience we assume logic to be a uniform field, which is, of course, not the case; cf. Honderich, *Philosophy*, 496-511, cf. also p. 63.

[12] This problem is also touched on succinctly by Kemp, *Ancient Egypt*, 100, referring to the texts of the Edfu temple: "These building texts are rich in language-game (cf. above, n. 4) and symbolic geography, and incapable of resolution into a *single scheme of modern logical form*" (italics RvW); cf. also the quotation from Oosten, below p. 83.

[13] *ZÄS*, 114 (1987), 59-88, esp. 59-65; *SAK*, 27 (1999), 1-26, esp. 25, n. 80. To these may be added the contradictory interpretations of the topics of "fighting boatmen in papyrus skiffs" (Herb, *Wettkampf*, 1-16) and "the tomb owner pulling papyrus, while standing in a papyrus boat" (Munro, *Unas-Friedhof*, 95-118). Students studying the subject anew have been able to extend Munro's list of 16 references to literature (o.c., 133-136) to 26. They vary from a sober socio-economic interpretation (Herb, o.c., 361, n. 543), to that of a "hieros gamos" or "sacred marriage", (Munro, o.c., 98ff.) or a means of ascension to Heaven (Altenmüller, *Himmelsaufstieg*).

...Und wir dehnen unseren Begriff...aus, wie wir beim Spinnen eines Fadens
Faser an Faser drehen. Und die Stärke des Fadens liegt nicht darin,
dass irgend eine Faser durch seine ganze Länge läuft, sondern darin,
dass viele Fasern einander übergreifen...

...And we extend our concept...as in spinning a thread we twist fibre on fibre.
And the strength of the thread does not reside in the fact that some one fibre runs through its
whole length, but in the overlapping of many fibres...

Wittgenstein, Philospohische Untersuchungen, 67

4.2. "Sehbild"/"Sinnbild"

The contradictions so far established concern the problem of the interpretation of the representations. Are they just *visual* images with a *literal* meaning in a one-to-*one* relation, coinciding that is with a representation of the optically observable, material reality ("Sehbild" in German, e.g. fishing is just fishing)? Or, are they *mental* images having a *literal* plus a *metaphorical* or *allegorical* meaning in a one-to-*two* relation with material and immaterial reality, coinciding with a representation of the optically observable, material, but in fact ideological and/or *ideational* reality ("Sinnbild" in German: fishing is not just fishing but refers to something beyond this).[14] The following examples of this dilemma may speak for themselves.

I. Junge, for instance, interprets the Old Kingdom elite tomb as a "house".[15] This may possibly hold for multi-room tombs, but does it apply to single room cases, as Kessler correctly observes?[16] Junge argues that the decoration is primarily a status symbol,[17] while Kessler apodictically concludes that the "...Alltagszenen, ...primär, wie *alle* (italics RvW) anderen Grabbilder auch, die Aufgabe haben, den Grabherrn an dem magisch-religiösen Geschehen der Festverjüngung...nach königlichen Vorbild teilnehmen zu lassen".[18] Note that his statement is based on three large tombs[19] plus some scenes in smaller tombs,[20] altogether no more than a handful. The rub lies in the fact his analysis of this statistically extremely slim material, results in a statement concerning *all* "secular scenes", without rendering any account to the reader to resolve the question of how many scenes of ships are involved in proportion to the total number of tombs with "secular scenes". A case of sweeping induction, indeed!

[14] Cf. for these German terms, e.g. Kessler, *Bedeutung*, 60-65 and Buchberger, *Harfnerlied*, 95-96. The reality of a one-to-one relationship of a photographically correct image with a "distorted" representation drawn by Egyptian artists is neither denied nor influenced by the "perspective aberrations" in such drawings, because these result from typical Egyptian drawing conventions. For instance, the "impossibly" large size of the fowling tomb owner does not refer to a meaning different to and hidden "behind" the real situation. It only indicates or "symbolizes" that he is the focus of attention and of a substantially higher social stratum than his fellow companions; in short the person remains the same. This is quite different from Altenmüller's "allegorically" symbolic meaning where the tomb owner plays the role of the "triumphant Osiris" (cf. p. 74).

[15] Junge, *Sinn*, 57-58; an interpretation dating back to Scharff's *Grab als Wohnhaus*, an interpretation maintained by Brinks, in *LÄ*, III, 1215, s.v. "Mastaba" with n. 12.

[16] Kessler, *Bedeutung*, 64.

[17] Junge, o.c., 56-57.

[18] Kessler, o.c., 88.

[19] Namely the tombs of Ti (o.c., 66ff.), Niankhkhnum and Khnumhotep ("The two Brothers"; id., 74ff.) and Mereruka (id., 67ff.), all located in Saqqara.

[20] See for instance, the tomb of Kaiemankh at Giza, o.c., 64ff.

A proper answer to this certainly not unimportant question implies more than clinical observation: in so many tombs there are such scenes, in so many there are not. So far, only eight scenes of shipbuilding (cf. fig. 9, top, p. 59) have been found among the 307 tombs inventoried by the Leiden Mastaba Project, less than 3 per cent! Leaving Kessler's good intentions unimpeached, one may wonder in all seriousness whether the marginal importance which these scenes apparently had for the ancient Egyptians, concurs with his sweeping conclusions. Even "sailing ships" (cf. fig. 4, bottom), the most frequent sub-theme of the main theme "ships", occurs in only thirty-five tombs, 11,4 per cent.

The dominant mechanism that Egyptological interpretations of tomb iconography reveal is that one (often implicitly) takes the representations (with or without inscriptions) as representatives of *one* language-game, usually the religious. Simultaneously one makes a one-sided choice about how all scenes should be understood. Either they are considered as a "Sehbild", a reflection, of the once existing reality, which although primarily self-referential to the "here", might (in the event) be projected to the "Hereafter", in line with the earlier mentioned Egyptological idea about this.[21] Or they are understood as a "Sinnbild", as metaphorical or symbolic representations, that is, primarily hetero-referential to, by nature, abstract, conventionally fixed ideas, concepts or rituals.[22]

II. Consequently, some thus interpret the scene of the tomb owner spearing fish, while accompanied by his wife (fig. 11, p. 60), as symbolizing their sexual union as a guarantee of the rebirth of the former in the Hereafter.[23] All this is based on a (supposed) pun between the Egyptian verb *stì*, which means "to shoot", "to spear"[24] and *sṯì*, "to beget" (known only since the Middle Kingdom (!)), which is metaphorically derived from the Old Egyptian *sṯì*, "to sow".[25] Therefore, Feucht observes quite rightly that this might have been the case in the event a wife would always be present[26], and, preferably then, *in front of* the husband.[27] Cogently, how does this "explanation" or "interpretation"

[21] Cf. p. 62 with n. 75.

[22] See for some fundamental matters, Kessler, *Bedeutung*, 60-65.

[23] Kessler, o.c., 65, n. 37, referring to Westendorf, *Bemerkungen*. However, Westendorf does admit that this type of scene "[den] hier *vermuteten* (italics RvW) Nebensinn nicht immer gehabt hat", but had become ambiguous only since the 5th dynasty, when the "deceased" (cf., our remark on this on p. 62) is no longer just an observer, but plays an actual part: Westendorf, o.c., 143, n. 22. The real crux to be solved here is the fact *that* (a supposed) ambiguity emerged after the 5th dynasty: what factors and/or needs caused this to happen and why? What proof do we have of this change?

[24] *WB*, 4, 324,1ff.

[25] *WB*, 4, 347, 10ff.; 346, 13ff.; Hannig, *Wörterbuch*, 1 (covering only Old Kingdom and First Intermediate Period), 1252 and 1262, records only "to shoot" and "to sow". Note that the metaphorical extension of the original "to sow" had to be made explicit by the determinative of the phallus (with liquid issuing from it): Gardiner, *EG*, sign-list D 52-53. Cf. also Feucht, *Fishing*, 159.

[26] Feucht, o.c., 160.

[27] O.c., 164.

fit the cases where there is no trace of a wife, as in the Leiden chapel (fig. 13, p. 76), or where a son, standing in front, hands the fishing-spear to his father (fig. 12, p. 75)? Is the latter case an example of father-son incest?[28] Finally, what about women/wives were they not equally in need of rebirth or regeneration in the Hereafter?

These critical questions may (luckily?) seem to be able to be circumvented by paying no attention whatsoever to the human participants, but by concentrating on the speared fishes: tilapia[29] (left fish of fig. 13) and *Lates niloticus* or Nile-perch[30] (right fish, id.). At a much later time and in a completely different context, the tilapia appears to be a regenerative symbol, since the young fry, swimming out of the mouth where they have been hatched, seem to be a textbook example of *generatio spontanea*.[31] What would seem simpler than that the tomb owner has provided himself metaphorically with his own regeneration by hunting this fish? Alas, the other fish is a Nile-perch, of which, in the present context, there is not known a single symbolic meaning throughout the entire Old Kingdom.[32] In addition, concomitant texts do not refer in any way to a possible double meaning of the kind discussed here.[33]

By contrast, the proposed interpretation by Brewer and Friedman is that, since the two fish can never be caught together with one thrust of the bident because the *Lates* refers to the Upper Nile region and the tilapia to the Lower Nile region (their respective natural habitats), they may represent the unity of the two lands.[34] Although they do not elaborate what they mean by the "unity of the two lands", it is unlikely that it refers to the political unity rather then to the physical unity, in the sense that the tomb owner was able to fish throughout the entire land. This much more plausible interpretation seems to be underpinned by the text column in front of the owner in fig. 12: "Spearing fish…in the bird pools of Upper and Lower Egypt".

[28] Once one has started interpreting this kind of scenes symbolically, this is certainly by no means an outrageous thought, see, e.g. Weeks' remark concerning this topic in *Art*, 60 with n. 7. However, if one sticks to the "ordinary" interpretation – just spearing fish – then one readily subscribes to Feucht's remark, *Fishing*, 164: "Even if the sons accompanying their father with a throw-stick (= equivalent of the harpoon, in the scene of fowling with a throw-stick, to be presently discussed, RvW) are not actively taking part in the sporting game, they cannot be the product of the procreation. If that were the case, they certainly would not be holding the tool of reproduction or even use it themselves".

[29] Brewer, Friedman, *Fish*, 76-79.

[30] Cf. o.c., 74-75.

[31] Feucht, *Fishing*, 165 with n. 29.

[32] Unambiguous indications of the special meaning of the Nile-perch are only known since the Late Period, cf. Gamer-Wallert, *Fische*, 129-130. Furthermore, it is remarkable that the Nile-perch does not occur as a regenerative symbol on scarabs, but the tilapia does, cf. Hornung, Staehelin, *Skarabäen*, 110-111.

[33] Feucht, *Fishing*, 160.

[34] Brewer, Friedman, *Fish*, 79.

III. Via a (supposed) pun with the word *ḳmȝ*, "to throw" and "to create", "to beget"[35] the same ambiguous meaning is ascribed to the scene of fowling birds with a throwing-stick, which is not infrequently depicted antithetically with the previous scene.[36] Caution is advisable and one should take note of the fact that the word *ḳmȝ* in relation to fowling is recorded by the *WB* only since the New Kingdom.[37] In the Old Kingdom only the word *ʿmȝ*, "to throw a throw-stick (substantive *ʿmȝt*)"[38] is recorded in some elite tombs. Feucht goes on to observe that, if the scenes of spearing fish and fowling with a throw-stick were really symbolically identical or at least connected, a regenerative symbolism of the birds that are caught should be expected as well. So far, it has not been found.[39]

The extremely speculative interpretation of this double scene in the tomb of Niankhkhnum and Khnumhotep by Altenmüller – and its extrapolation from this single example to all other identical ones – namely the tomb owner in the role of Osiris, his wife acting as Isis, his daughter as Nephthys and the eldest son as Horus in the context of the embalming ritual, symbolizing the revival and triumph of the deceased,[40] is unlikely for several reasons. Why one of Niankhkhnum's titles, viz. "priest of Re", should connect him to the role of Osiris remains unexplained in the complex reasoning of Altenmüller. Pertinently, one only needs to consult our fig. 11 to see that the "necessary" daughter in the role of Nephthys is entirely missing there, leaving us with three, instead of the four requisite actors. Nor is Neferirtenef's son a "wab-priest of the king", a title that would equate him with Horus in Altenmüller's view. What about our figs. 12-13, where only one, respectively two identical sons are the only company present? Altenmüller would have a case if all examples showed the same number of "actors" and identical titles. Now, similar to or rather worse than Kessler, he draws sweeping conclusions on an even smaller number of cases: *one* example only. Correctly observing in his n. 80 (p. 25) that these scenes are very diversely and controversially interpreted, he just adds another suggestive but unprovable interpretation to the list.

[35] *WB*, 5, 33,8ff; 34,18ff.

[36] Feucht, *Fishing*, 158-159; Westendorf, *Bemerkungen*,142; *LÄ*, VI, 1052, s.v. "Vogelfang".

[37] *WB*, 5, 33,12.

[38] Hannig, *Wörterbuch*, 271.

[39] Feucht, o.c., 165. Herb, too, says in *BiOr*, 646: "Gerade für die Szenen des Alten Reiches bereitet ein bloss übertragene Sinngehalt bei der Interpretation der Wurfholzszenen erhebliche Schwierigkeiten". It confirms *LÄ*, V, 280,18 with ns. 47-48 (s.v. "Rituale") in which, especially in n. 48, the regenerative meaning through an erotic sense is characterized as speculation.

[40] Altenmüller, *Isis*, 20-26. Myśliwiec, *Merefnebef Hunting*, 293, accepts this interpretation.

Fig. 12. Wall in the tomb of Pepiankh Heneny, Meir.

Therefore, for the time being, it seems wiser to depart from the actual reality of such scenes, where, additionally several texts explicitly mention the aspect of pleasure or diversion. Very instructive are the framing texts of the scenes in our fig. 3, p. 36: "Observing the marsh pools, fowl pools, back swamps, fishing and fowling, *more beautiful* to see (absent in right col.) than anything". Apparently the core of the matter is a purely aesthetic appreciation. There is not the slightest reference to a supposed location of the scenes in the Hereafter ("the beautiful West", "place of eternity" and so forth), or that they are meant to keep the *ka* alive after death.[41] Thereby, a *possible* metaphorical excess value is not denied on principle, but one does not assume from the very start that *all* scenes of the type of the fish spearing and/or fowling tomb owner in the marshes necessarily have a sexual, respectively regenerative connotation.[42] However, by taking the various, potentially present language-games as a starting-point, it is possible – through the variation in composition with regard to the minor figures – to nuance the sub-themes of "the owner spearing

[41] Feucht, o.c., 165ff; cf. for other examples Fitzenreiter, *Grabdekoration*, 136, 138, 140.
[42] Cf. also Buchberger's methodologically excellent article, *Sexualität*, 42,XI, which came to my attention after the Dutch edition of the present study was published.

Fig. 13. Wall in the tomb of Hetepherakhty, Leiden.

fish", respectively "fowling with a throw-stick". One cannot stress too highly that exactly the *minor figures* (unequivocally characterised by their smaller sizes),[43] whose social and family positions are made explicit by captions, (at least partly) reveal the interpersonal relations of the act and thereby stress the acting *principal person*. The regularly complete absence of women/wives (figs. 12-13) makes it absurd in my opinion to continue to insist on reading a

[43] There are hardly any or no differences in size in only a rare case, e.g. Feucht, *Fishing*, fig. 5, a provincial tomb.

sexual connotation into these scenes.[44] Here, rather the language-game of the tomb owner as a sportsman[45] in the relationship father-son is represented. His role as "pater familias"[46] is expressed by his being accompanied by his wife, son(s), daughter(s), servant(s) and even a brother.[47] Of course, the presence of his children implies a sexual relation with his wife as a *conditio sine qua non*.[48] Enforcement of this aspect *might* be expressed by stressing the female element: either with his wife alone, or with more female persons. In other words, the variants show a possible (textually never explicitly stated) hetero-sexual[49] connotation, which may *gradually* run from absent to (dominantly) present. The tomb owner's choice of a variant made, and still does make, clear where the main accent lay for him.

The contradictory dichotomy in the interpretations offered here is immedi-ately removed as soon as one realizes that fish and fowl represent categories of *food*. The husband/father, as head of the household/family, by nature, bore the prime responsibility for this. *He* went out hunting for his entire family, in depictions represented by the two sexes. Pertinently, for the sake of continuity, he had to train his sons(s), expressed in representations depicting (only) the male sex. Since in Egypt the household, respectively the family, was the basis of the social order, it is obvious that the fundamental function of the husband/father[50] remained *ideologically* unchanged, although *actually*, once raised to the level of the elite, he no longer practised it. The fact that the hunt for daily food was no longer necessary for this class, automatically lends the previously mentioned "sportive" and "recreational" and thus a "high status" character to the continuance of the practice all the same.[51] One might compare it with the

[44] Quite correctly, Feucht, o.c., 159, n. 13, refutes Kessler's solution for the absence of women. If one, indeed, assumes that the Egyptian who was familiar with the theme supplemented the figure(s) in his mind, there is no end to utterly uncontrollable speculation on meaning. One may state with equal certainty that the Egyptians of the Old Kingdom supplemented gods and kings – well known from later periods – "in their mind's eye". But, if true, one still has to answer the question *why* a complete scene was incorporated in one case, but not in another. Lack of space cannot be the answer. Hetepherakhty (fig. 13) could easily have had his wife represented (if he had one, there is no trace of her in the entire chapel!) between his legs (cf. fig. 11), instead of the same son twice in front and behind. Some quantification on the absence of women in tombs is found in Roth, *Absent Spouse*, p. 39-40, tables 1-2; her conclusions, again, are often speculative and far-fetched.

[45] *LÄ*, VI, 1052, s.v. "Fogelfang" states this as an incontestable aspect of such scenes. See also Harpur, *Decoration*, 180-181, esp. 181.

[46] Cf. Kanawati, *Living*, 213-214 and *LÄ*, VI, 913, s.v. "Vater" for the close family ties.

[47] Feucht, *Fishing*, 163 with fig. 7.

[48] Cf. Buchberger, *Sexualität*, 24.

[49] This is, after all, the only possibility of guaranteeing the continuation of life, both here and in the Hereafter.

[50] *LÄ*, II, 104-113, s.v. "Familie"; o.c., VI, 913-915 s.v. "Vater". Cf. also Kaplony, *Methethi*, 18-20, referring to wisdom literature stressing training.

[51] This is also observed by Assmann, *Sinngeschichte*, 46, who locates its roots as early as in the Nagada Period.

falconry of the nobility in the Middle Ages. The fact that the king as a kind of "super head of the family"[52] was responsible for the welfare of all Egyptians makes it logical that this type of scene is also found in royal context, where it is revealing that a wife occurs in the oldest representation,[53] obviously referring to this broader domestic context.[54] Nor should one forget the sometimes very ancient familial organization of several deities. Although the function of the king in the *personal* familial context is identical to that of the non-royal husband, precisely his position as king lends this scene a hetero-referential, symbolic excess value: the expression of the *office* of kingship that by definition is absent in private tombs.[55] If one adheres to the sexual connotation, which is based particularly on New Kingdom representations,[56] one is making the methodological mistake of projecting a certain content of a late(r) scene onto a formally more or less identical but temporally much earlier one.[57] It ignores or even denies a possible historical evolution of the content of the latter. In addition, it still leaves the question, *why* these scenes with the exception of Eje's tomb,[58] completely disappear from royal iconography in the New Kingdom to be answered.

Still another aspect, the psychological, deserves to be mentioned. Individual capability and skill play a decisive role in hunting with a fishing-spear or throw-stick: the hunter after all catches every animal separately by personal skill in aiming at and hitting his target. Success in these forms of providing food would have built up the ego more than any scenes of the collective hunt with, for example, the hexagonal net. This might explain that, apart from a rare exception,[59] the tomb owner does not take an active part in this scene in later

[52] It is interesting to note that, although much later, Ramses II was literally called "husband of Egypt", *LÄ*, I, 809 with n. 15, s.v. "Bildliche Ausdrücke…"

[53] Cf. Vandier, *Manuel*, 4, fig. 399,2, tomb complex of Sahure, 5th dynasty. The ivory tablet fragment from the time of Den (o.c., 1, fig. 569) is too fragmentary for thematic identification: the fish spear, raised in the right hand, has only partly been preserved.

[54] The fundamentally "patrimonial" form of control that runs the state as a kind of family estate, finds its origins, according to Assmann, in the Thinite Period, id., *Sinngeschichte*, 60-61.

[55] Cf. Junge, *Sinn*, 51ff.

[56] Cf., for instance, Harpur, *Decoration*, pl. 17. Here the added text "… in the place of eternity…" which has so far never been found in the Old Kingdom, suggests a (literal?) projection of the scene into the Hereafter.

[57] Kemp summarizes the problem excellently in *Ancient Egypt*, 89: "We tend to work by trying to identify fossils of early beliefs embedded within later sources. Yet if we take this *easy* (italics RvW) course we run the risk of substituting for ancient language-game a modern scholarly game". Cf. Buchberger, *Sexualität*, 24-25, 43.

[58] Piankoff, *Aï*, pl. 21.

[59] In the tomb of Ti, see Harpur, *Decoration*, fig. 76. In the tomb of Nefermaat and Itet (o.c., fig. 170) there is the unique scene where Nefermaat *alone* operates such a net, while in two other scenes in the same tomb two (o.c., fig. 168; note that the numbers 168 and 169 must be interchanged), respectively four (id., fig. 171) sons do this. The scenes are fully treated in Harpur, *Maidum*, 81-82 (fig. 82), 231 (fig. 169), 241 (fig. 177) [Nefermaat]; 86-87 (fig. 86 [2 sons]); 77-80 (fig. 81). Note Harpur's comment on the first scene: "The scene on the architrave can be

periods. In short, the least far-fetched or tortuous interpretation of these scenes is taking them as primarily referring to actual reality (cf. p. 36, n. 36).

However, what may easily trick us is the Egyptian artist's ability to construct convincing representations through the "association of ideas",[60] in which (all) elements were not necessarily in each other's presence during the actual operation. It still tempts us to take these scenes literally visually and to interpret the ensuing – for *our logic* – unlikely, if not impossible, configuration of figures and/or attributes metaphorically or rather purely symbolically as a consequence. After all, scenes of complete or incomplete families transported in [in *our* opinion] *overly small* papyrus skiffs, wearing their [in *our* opinion] *good* clothes while "recreating" by [in *our* opinion] *"messy"* fowling and fishing activities are [in *our* opinion] "impossible", and [in *our* opinion] "therefore" they should not be taken at face value.

Nevertheless, the instrument of the association of ideas makes the interpretation concerning the familial position and relations of the tomb owner offered on the previous page, highly plausible.[61] The "festive attire" too, by no means vitiates the sportive and/or recreational aspects. The ability to contribute only *partly* to the food supply in a "sportive" way is a pre-eminent sign of high social status, a status which is underlined to a nicety by having oneself represented wearing one's "good dress", even if one (of course?!) would not have worn it during the actual activity. Cogently, this approach certainly does not exclude a sexual undercurrent, but it is only a potential *part* of the complete range of messages that are transmitted by different (pictographic) language-games in such scenes, and no longer the *only* acceptable one among them. Reducing all iconography to a single "essential" meaning/function (cf. above p. 72) is based on an unfounded prejudice.[62]

Finally, regeneration is of equal importance to everyone. What, then, is the explanation for the fact Vandier in his *Manuel* has found only thirty-five specimens for the Old and Middle Kingdoms together, of which twenty belong to the former period?[63] Hence, this theme too reveals a high degree

interpreted in two quite different ways: Nefermaat shown as *a resourceful provider for his wife and children* (it. RvW), or Atet honoured by offerings from *her offspring through the efforts of her husband* (id.; note the collaboration of father and sons in the latter case with regard to our observation on this point on p. 77)...the natural movement of one's eye,..., is to the figure pulling the net, *the provider* (id.), Nefermaat".

The unique character of the scenes of Nefermaat and Ti, interpreted as expressing individuality, are discussed in Van Walsem, *"Individuality"* (in press).

[60] Irrefutably demonstrated by Schäfer, *Principles*, 160-162, 166, 193-195.

[61] Cf. Kanawati, *Living*, 213: "As it is obviously unlikely that wives and children participated in these occupational activities, their existence in such pictures perhaps reflects the Egyptian's continuous desire to be inseparable from his family"; cf. also Buchberger, *Sexualität*, 26-27.

[62] Wittgenstein uses the same term for the idea about the supposed, but non-existent "essential function of language", cf. Allen, Turvey, *Wittgenstein*, 8, 10.

[63] Vandier, *Manuel*, 4, 718-719.

of "dispensability". A plausible indication that the here criticized interpretation of a regeneration/rebirth[64] in the Hereafter was apparently so deeply hidden that an unintentional misunderstanding about it might arise among the Egyptians themselves too, is suggested by the fact that these scenes are totally lacking in the 19-20th dynasty tombs, whose iconography refers dominantly to the Hereafter.

However, the issue taken as our example of the opposition "Sehbild/Sinnbild" seems to be ingeniously solved by Junkers's statement: "Alles ist Sinnbild und Wirklichkeit zugleich".[65] Is this really so, and does it say everything?

Such statements can be falsified fairly easily for our own culture. The motive of a man carrying a lamb on his shoulder in early Christian catacombs, on sarcophagi or as a statue is not *a* shepherd, but the Good Shepherd, Christ, who is taking care of the faithful (the lamb). In other words, it is indeed primarily a symbol or Sinnbild.[66] Going one step further, one should realize, that the lamb, respectively sheep in the configuration of the Good Shepherd has a completely different meaning than the lamb in Hurbert and Jan Van Eyck's "Adoration of the Lamb" on the altarpiece in Ghent, where it now stands for Christ himself, referring to His sacrificial role as Saviour of mankind.[67] Two completely different forms: herdsman-animal may refer to the same person: Christ; while the same form: lamb/sheep may refer to two different persons: Christ, respectively a Christian.[68] Proof of these interpretations is provided by a text, itself originating from the Christian milieu and unequivocally belonging to the religious language-game, namely the Bible. It certainly would be absurd, to read a symbolic meaning into every lamb/sheep in Western visual arts, and therefore declare each representation with this animal a religious one.

The ancient Egyptians have *their* herdsman motif of a man with a calf on his back as represented, for example in the tomb of Ti (± 2350 BC; fig. 14, p. 82). Now, one may ask whether there is a text in- or outside the elite tombs that tells us whether this scene might be interpreted analoguously to the Christian example, as a "Good Shepherd" motif too. The herdsman might then refer to a deity or the king, who was not literally called *mnìw nfr*, "Good Shepherd" before Amenhotep III (± 1370 BC).[69] In short, had this scene a primarily symbolical meaning for the Egyptians or was it just seen as part of a fording scene which referred to real existence. In my view, the caption removes any possible doubt. The first herdsman is addressed by his colleague in line one as:

[64] For a critical discussion of this term, see Buchberger in *LÄ*, VI, 1246-1261, esp. 1251,D.

[65] Cf. Junker, *Gîza*, 5, 73, quoted by Kessler, *Bedeutung*, 65.

[66] Cf. Gough, *Christians*, 66, pls. 9, 13, 14, 35 (Dutch edition).

[67] Cf. Janson, *History of Art*, 358-359, fig. 463.

[68] More contradictory identifications of Christ and the phenomenon as such are mentioned, respectively discussed by Redford, *Kingship*, 162-163.

[69] Cf. Müller, *Gute Hirte*, 135. For the most recent and complete discussion of the scene, cf. Van Walsem, *Cattle-fording Scene*.

"Oh, shitter…"[70] It is unlikely, to put it mildly, that in analogy to the Christian example, these are words with which an ancient Egyptian would have addressed the king or a deity, even if the latter were disguised as a herdsman. Even if the text were not a dialogue between herdsmen, but a magical spell against crocodiles, as suggested by Ogden,[71] then the representation as such still refers primarily to the real existence of the herdsmen, who during their work call upon a segment of their ideational existence to enhance the chance of success for their undertaking (cf. fig. 15 from the 6th dynasty tomb of Ankhmahor). This ideational *segment* thereby, does not turn the entire depiction into a magical, or an ideational one. Nor is there any indication that justifies an allegorical meaning.

Two examples from Western art may illustrate the point in more detail. Giulio Romano's fresco "The victory of Constantine over Maxentius at the Milvian Bridge" (± 1520),[72] which represents an objective, historically unique event, but simultaneously symbolizes the victory of Christianity over paganism: "Seh- and Sinnbild" united as equals, indeed. Both interpretations are confirmed by texts that belong to the language-games of political and church history.

David's painting, showing Marat murdered in his bath-tub (1799),[73] neither symbolizes the defeat of the revolutionary nor the victory of counter-revolutionary forces during the French Revolution. It is primarily a representation to commemorate this violent act perpetrated against a prominent leader of the Revolution: "Sehbild".

Summarizing, one can but conclude that only *texts* from the culture itself may unambiguously indicate whether a representation is more than self-referential, as shown by the example on p. 75 with n. 41. In other words, not a single "Sinnbild" can discard "Sehbild" elements and therefore so far Junker's remark remains valid. A "Sehbild", however, can be completely devoid of "Sinnbild" elements. Therefore, not "Alles", not even in the limited context of Old Kingdom tombs, is, by definition, both "Sehbild and Sinnbild" simultaneously. Establishing, whether, where and to which *degree* one turns into the other is essential to achieve a clear and sound understanding of a complex system which is what (the iconographic programmes of) elite tombs are.

[70] The Egyptian *mḥśḥś* is an active participle, substantivized by *m*, of the intensive verb *ḥśḥś*, derived from the single root *ḥś*, that means, politely said, "faeces/excrement", but in view of the vernacular context has been translated here in coarser language; cf. Van Walsem, o.c., 1475. Edel, *Grammatik*, §256, takes it, without further comment, as a passive; cf. too *LÄ*, V, 634-638, s.v. "Schimpfwörter". Ritner, *Magical Practice*, 225 translates it as "shitty".

[71] As quoted in Ritner, *Magical Practice*, 225, n. 1047, the most recent discussion of the scene, preceding my own, cf. note 69. The present case would represent an utterly anomalous variant of the usual anti-crocodile spells; cf. Ritner, o.c., 227 for an extensive example.

[72] Gombrich, *Norm*, fig. 162.

[73] Janson, *History of Art*, fig. 737.

Fig. 14. Cattle fording scene in the tomb of Ti.

Fig. 15. Cattle fording scene in the tomb of Ankhmahor.

A first step towards accomplishing this aim is the realization (mentioned earlier on pp. 30-31, 35ff., 63, 65, that reality is very complex both for us and the ancient Egyptian, witness the complexity of the iconographic programmes in the tombs. This means that it is possible to speak about reality in many various ways, either in words, representations or in both.[74]

[74] The functional relationship representation-caption is complex. Why is a caption omitted in one scene (although there is space), while it is present in another, more or less identical one? Why is it once an explicative (= timeless) caption only, the other time a dialogue (= momentaneous)

A quotation from Oosten's *Magic and Reason* summarizes this in a crystal-clear fashion: "It depends on the concrete situation and the intentions of the speaker, which aspects of reality are stressed and which are ignored as irrelevant for the moment. Somebody walking in Paris may one time pay attention to the purely aesthetic aspects of his surrounding area, another time to the age of the buildings, the shops, the underground stations or the contrasts he observes. Each time he wants to verbalize what he sees, he is in need again for other words. Different aspects of the same neighbourhood are described by means of different language-games. There is no sense in stating that *one* of these language-games is by far the most suitable for describing the reality of Paris".[75] Is the situation any different in the case of the iconography of an ancient Egyptian elite tomb?

only, or in another case a combination of both? Why are the captions in one type of (sub)-theme rather uniform or stereotypical (e.g. agriculture) but (very) heterogeneous (e.g. jousting boatmen) in another? Why does one type of caption tend to expand in length in contrast to another? Why are the secondary figures in one tomb anonymous, while in the other they are provided, often secondarily, with titles and/or names? Did "costs" play a role: no captions save time = cheaper; painted ones are quicker = cheaper than sculptured ones? Were there any "rules" concerning this issue, they have escaped us for the time being. Anyway, all this seems to underline the freedom of choice discussed earlier (cf. p. 58-60. Cf. also Herb, *Wettkampf*, 37 and his index s.v. "Hand-lungs, Namens- Redebeischrift"

[75] Oosten, *Magic and Reason*, 7-8; cf. also p. 11, n. 13.

…- Richtig und falsch ist, was Menschen sagen; und in der Sprache stimmen die Menschen überein. Dies ist keine Übereinstimmung der Meinungen, sondern der Lebensform.

…- It is what human beings say that is true and false; and they agree in the language they use. That is not agreement in opinions but in form of life

Wittgenstein, Philosophische Untersuchungen, 241

…- Was die Menschen als Rechtfertigung gelten lassen, – zeigt wie sie denken und leben.

…- What people accept as a justification – is shewn by how they think and live.

Idem, 325

4.3. FORM OF LIFE

The collection or set of language-games[76] someone will use during his life determines what Wittgenstein calls his "Lebensform" or "form of life" and makes it a very *complex* whole.[77] It embodies an *individual* aspect but, since individuals do not function in a vacuum (language-games are necessarily learned from behaviour of others), has a *collective* aspect as well. This is excellently summarized by McGinn: "… just as the term 'language-game' is meant to evoke the idea of language in use within the non-linguistic activities of *speakers* (it. RvW), so the term 'form of life' is intended to evoke the idea that language and linguistic exchange are embedded in the significantly structured lives of *groups* (it. RvW) of active human agents….a form of life applies rather to historical groups of individuals who are bound together into a community by a shared set of language-involving practices. These practices are grounded in biological needs and capacities, but insofar as these are mediated and transformed by a set of intricate, historically-specific language-games, our human form of life is fundamentally *cultural* (rather than biological) in nature".[78]

Consequently, through its cultural nature a form of life represents both a way of life and a way of interpreting the world,[79] and comes close to Panofsky's "essential tendencies/content" (cf. p. 21-22), and Huizinga's "*Forms* of life and thought…" (cf. p. 65), but is even more comprehensive than these. Wittgenstein, namely, deepens the concept by revealing that, in McGinn's words, the "…distinction between the living and the non-living, whose roots lie deep in the grammar of our language"[80]…enters into the *fundamental structure of our form of life* (it. RvW); it represents the *form of our world* (id.). It is tied up not merely with what we say, but with all our ways of acting and responding to the world. Therefore: '[our] attitude to what is alive and to what is dead is not the same. All our reactions are different' (*PI 28*)".[81] The difference in our attitude itself is grounded in the central language-games of all our acts, namely the psychological.

From this follows that by nature each human being tends to describe the world, existence that is, following his own rules, the languages-games and

[76] The fact that it concerns a *set* reveals that not a single element of the set is itself sufficient for the totality to be covered in communication. See above the quotation of n. 75.

[77] Cf. McGinn, *Wittgenstein*, 58-59, giving a list (from *Philosophische Untersuchungen* 23), containing, for example, the word/activity of "asking", which itself can be split up into new language-games/activities, e.g.: questioning a murder suspect, asking someone to marry one and so forth.

[78] McGinn, *Wittgenstein*, 51. "Biological capacities…" versus "cultural", parallels our "biological" versus "cognitive and rational" of p. 34.

[79] This is also noted by Oosten, o.c., 10.

[80] McGinn, o.c, 153.

[81] Id., o.c., 154. This also refers us back to what is said about death on p. 33, first par. of 3.2.3.

form of life to which he is used.[82] When a group of individuals agrees about the "truth"[83] of a number of postulates concerning existential issues and the accompanying language-games, it is a matter of a collective form of life,[84] which, in view of its existential character, is strongly tied to the worldview.[85] Therefore, "...the concept of "form of life"...does not indicate in the first place the worldview *or* (it. RvW) emotional behaviour, but rather the complex *whole* (it. RvW),[86] of which both are a part and which is expressed in the way people live, including how they think, speak and behave".[87] At this point one enters the area of (the history of) mentality.[88]

The essence of the complexity of the elite tombs is that as an Egyptologist one should be sharply aware of the previously sketched, potentially hierarchical levels of the various language-games, whose combination and quantity represent the form of life of an elite (bearing in mind Englund's words),[89] including – at least – a part of their worldview/"philosophy of life". Perhaps unnecessarily, attention should be drawn to the fact that a philosophy of life encompasses the spheres of the "real" (cattle fording), the "ideational" (mentioning, respectively depicting deities in texts, respectively in iconography) and the "ideological" (the king as responsible for Egypt) existence (cf. p. 33-38).

One should bear in mind a few other aspects concerning the approach defended and propagated here.

Firstly, one should realize that all these different, often (seemingly) incompatible manifestations of the ancient Egyptian processing of reality may indeed be *stored simultaneously* in one building and/or iconographic programme. Yet, they cannot be *actualized all at once* by an observer. When an Egyptian approached a tomb directly for its explicit religious content, he only (had to) read the ritual texts, bypassing representations of agriculture, cattle fording and the like and vice versa. One may also describe the situation by taking as an analogue the concept of "superposition" from quantum mechanics: before analysis/description of a quantum phenomenon, the functions of both wave and particle are "simultaneously" superposed ("stored") in the quantum. The

[82] O.c., 104, 52, 157; Oosten, *Magic and Reason*, 12.

[83] On the variants of truth in a report (= description) on, e.g. "...the contents of a box..." and, e.g. "...a motive, a mood or a dream", as discussed by Wittgenstein, cf. McGinn, 160-161, and Kober, *Certainties*, 428-429, 434 ("Truth can only be determined in practice").

[84] Or, in McGinn's wording: "...a stable, unified language-game in which all the speakers of a language participate", o.c. 162; cf. also Stern, *Wittgenstein*, 102-103.

[85] Cf. also Oosten, o.c., 92.

[86] Cf. p. 68, n. 6-7.

[87] As formulated by Oosten, o.c., 93; cf. also Stern, *Wittgenstein*, 127, 191-192, Kober, *Certainties*, 417-420, and Scheman, *Forms of Life*, 383-410.

[88] Vovelle, *Idéologie*, 32 (Dutch edition): "...to approach reality more directly in all its complexity, in her totality". Cf. also p. 14, and 58.

[89] Cf. p. 29, n. 20.

scientist has to choose, under the overall language-game of mathematics, between the two sub-language-games describing a wave function *or* a particle function *subsequently* in order to describe the impulse/velocity *or* place of the quantum. Heisenberg's "uncertainty principle" precludes that both be done simultaneously.[90] Three drawings may visualize the issue. Jastrow's "duck-rabbit", and "Necker's cube" – protruding (*a* being the front and *b* the back plane), respectively receding in space (*b* being in front, and *a* at the back) – unambiguously demonstrate that it is impossible to see both possibilities simultaneously: in a split second the brain *has* to switch from the one to the other (fig. 16).[91] Also, following Steinberg's line in fig. 17[92] from either direction results in a switching of the interpretation of its function, entirely dependent on its context.

Secondly, our etic point of departure makes it by definition difficult to distinguish the different character of those manifestations immediately.

Thirdly, our keeping an eye open for a possible plurality that must have certainly existed[93] is hampered. Cogently, this arises inexorably from the fact that in our culture the seemingly obviously dominant, the almost single, function of the tomb is a *marking* of the place where the mortal remains of a deceased are located. Possibly present forms and/or texts may indeed refer to a religious creed,[94] but the continuation of the (posthumous) ontological status or well-being of the deceased (e.g. in Heaven) is not dependent on them. Pertinently, in Egypt, the mass of representations connected with the tomb owner seem to lay extreme stress on a single aspect, at the expense of that of a marking, namely the *cultic function*. Because of this, the Egyptologist – already

[90] For a more detailed discussion cf. Van Walsem, *Chaos*, 321-323.

[91] Idem, o.c., 323. The duck-rabbit is also discussed by Wittgenstein in the *Philosophische Untersuchungen*, part 2, xi (cf. Anscombe, 194-194e; McGinn, *Wittgenstein*, 190ff.; cf. also Gregory, Zangwill, *Mind*, s.v. "Illusions", 340, fig. 4a) and the cube in his *Tractatus logico-philosophicus*, 5.5423 (cf. Sluga, *Wittgenstein on the Self*, 326; Gregory, Zangwill, o.c., 340, fig. 5 and 508, s.v. "Necker cube"); cf. also Hagberg, *Art as Language*, 142, 177.

[92] Cf. Gombrich, *Art and Illusion*, 200-201, fig. 200; for other examples of Steinberg's ambiguous drawings, id., *Steinberg*.

[93] See too, Kemp, *Ancient Egypt*, 89, who observes correctly: "The modern world recognizes that cultural expression appears at more than one level....We should be prepared in studying ancient societies to encounter the same plurality of expression"; "pluralism" is also mentioned in relation to Ma'at, by Quirke, *Ma'at*, 222, end of page.

[94] A prominent example of the appearance of this single function of a tomb as a marking in our culture is provided for example by the war cemeteries of World War II. Although at first sight a seemingly identical mass of crosses they are indeed differentiated by, e.g. a Star of David: marking *and* expression of a certain ethnic identity, it is not explicit whether the individual concerned had a religious bond with this group. So the marking aspect remains dominant.

Finally, the obelisk on Champollion's tomb in Père Lachaise expresses more than anything else – besides all connotations that this mark had already bestowed on other tombs during Romanticism – his lifelong devotion to the culture from which this shape originates. However, only people who know "the rules of the (language) game", i.e. they who are informed about the history of Egypt(ology), can both see and understand this latter connotation.

tending by nature to use a single language-game, namely the scientific – is unconsciously tempted to capture the interpretation of the complex phenomenon of the elite tomb in one denominator: a religious content for *all* representations (cf. pp. 69 and 72). This prevents him asking deeply enough whether this agrees with the Egyptian view on this matter. The fact that certain (groups of) scenes may indeed refer to a single frame of reference partly explains and, moreover, strengthens this uniformist tendency. It is essential to remember this frame of reference concerns, in the first place the (group(s) of) scenes in question. It does not justify the interpretation, in spite of the observable differences, of other scenes – even closest ones – in the same way, as for instance, spearing of fish and fowling with a throw-stick, regularly represented in a close connection. Failing to heed this warning, as demonstrated on pp. 71 ff., one is confronted with contradictions and/or far-fetched argumentations that justify Kessler's term "ägyptologische Fiktion",[95] the outcome of looking for *the essence* of an iconographic programme, respectively a tomb,[96] instead of accepting the diversity itself within "an indeterminate horizon of actual and potential use" as the essential.[97] The result is confusion about what to believe about the interpretations offered.

Fig. 16. A. Necker's cube; B. Jastrow's duck-rabbit.

Fig. 17. Saul Steinberg, Drawing from *The New Yorker*, 18 September 1954.

[95] Kessler, *Bedeutung*, 88.
[96] Cf. McGinn, *Wittgenstein*, 60.
[97] Id., o.c., 55, 59 167. Bolshakov, *Double*, 292 does acknowledge a fundamental heterogeneity in relation to the *ka*, and the ensuing inadequate interpretations resulting from this state of affairs.

A fourth and final, factor involved in this urge to capture a uniform inter-
pretation is the tacit assumption that someone's behaviour corresponds to his
philosophy of life. Oosten who observes this quotes from Van Baaren's *Gods-
dienstige voorstellingen en gedrag* [*Religious Ideas and Behaviour*], which
states: "...that there is a clear...discrepancy between the religious concepts,
...and the behaviour of the believer".[98] Oosten substantiates this with another,
in the present context, very apposite quotation from Van Baaren's publication
concerning Ancient Egypt: "Certainly, the hippopotamus and the crocodile
were sacred animals, but this did not impede the Egyptians from totally anni-
hilating these troublesome animals".[99] The harsh daily reality forced, such
people as the herdsmen who had to ensure their cattle could ford a crossing
safely to practise the secular and thus pragmatic language-game of their form
of life against the malevolent crocodile. That game did not consist solely of
reciting averting charms, as written over scenes of fording cattle and croco-
diles (fig. 15, p. 82),[100] but apparently also of actions, namely the actual com-
batting and slaying of crocodiles, although this has never been represented, as
mentioned before on p. 51.[101] A crocodile as a negative element in fording
scenes, however, is certainly not contradictory to the simultaneously positive
mention of the crocodile god Sobek in the Pyramid Texts[102] (however, never
in private tombs). Ultimately, those texts belong to the (royally "coloured")
religious language-game(s). No harm is done, as long as one does not try to
combine or mix elements from both language-games and forms of life into one
interpretation of crocodiles in private tombs, manufacturing a "logical
whole".[103] Note that, as said on p. 34, deities are never depicted in any Old
Kingdom private tombs. At the very most they are mentioned in the names and
titles of the owner.[104]

The examples demonstrate that within the form of life one should make a
distinction between what are called in the history of mentality "discourse" and
"practice".[105] As noted above, they may correspond (almost) completely, but

[98] Oosten, *Magic and Reason*, 98 (the translation is mine).

[99] L.c. Hill, *Prehistoric Cognition*, 90 gives some further telling examples of incongruity
between thought and practice ("...even though the Hindus...have a very strong religious ideol-
ogy prohibiting the killing of cattle, they do...systematically kill cattle....I submit that this kind
of incongruity is very common in all cultures,...").

[100] Cf. Harpur, *Decoration*, figs. 119-122, 211; Vandier, *Manuel*, 5, figs. 52, 62-65.

[101] Why the killing of crocodiles, in contrast to that of hippopotamuses, has never become an
iconographic topic is, I am afraid, an unsolvable riddle.

[102] §§489, 507, 510, 1564; in §456 he seems to have a negative connotation, since the crown
is taken from him, but this is a *different* spell (= "game").

[103] Cf. for another nice example, Buchberger, *Sexualität*, 40-41: three contradictory meanings
of "love"; cf. also Stern, *Wittgenstein*, 156, 169.

[104] Cf. Hornung, *Der Eine*, 32-33; see, e.g. Jones, *Titles*, 2, 573-574, nos. 2112-2114 for the
case of Sobek.

[105] Cf. Vovelle, *Idéologie*, passim, and Stern, *Wittgenstein*, 191.

they often do not. Although we acknowledge and accept this contradictory margin easily in our own culture,[106] we can hardly do the same or only do so with considerable effort for an older, especially foreign culture. It may too easily lead to the manipulation of the limits of our actual knowledge by making too uniform, reducing or even creating fantastic constructions of our interpretation/explanation for the alleged "contradictions". The problem about the limits of our interpretation and about how well-founded it is, especially in relation to our "fantasy" or "imagination" of the Ancient Egyptian culture has not only been excellently verbalized, but also visualized by Kemp.[107]

As said on p. 86, the iconographic programmes of the tombs under discussion are expressions of the form of life of the elite of the Egyptian society. Must such a form of life and its inherent philosophy of life or world-view be necessarily *uniform* in their expression, fixed in writing and picture language? Oosten also makes a very pertinent statement about this: "World-view and religion do usually pretend that they determine a form of life, but, because they are formulated so abstractly and informally that people of very different characters and needs are able to accommodate to them, they are actually compatible with various forms of life and various social ideologies".[108] This brings us right back to my earlier (p. 41) observation that man literally destroys the game by his free will. This agrees with my last quotation from Oosten: "Within the form of life the alternatives[109] are formulated, from which individuals may make their choice to shape their design of life", and "Every form of life has its own language-games showing how the world is described and which concepts play a key role in it".[110]

[106] "Hollandologists" of the distant future would easily get the wrong impression, based on the "discourse" of our traffic rules, that they were always applied, and that everyone was convinced of their usefulness. We, however, daily experience the difference in practice, which will be able to be substantiated by the archive of any arbitrary municipal court.

[107] Kemp, *Ancient Egypt*, 4-5, 104, fig. 38. Robins, *Problems*, 53, n. 50 joins him by quoting him, o.c.: "We can rethink ancient logic. But it creates an interesting pitfall, in that it is hard to know when to stop…We really have no way of knowing in the end if a set of scholarly guesses which might be quite true to the spirit of ancient thought and well informed of the available sources ever actually passed through the minds of the ancients at all. Modern books and scholarly articles on ancient Egyptian religion are probably adding to the original body of thought as much as simply explaining it in modern western terms." This also agrees with Gombrich's observations on over-interpretation in his *Limits*, 464 ("For taking the work as such, there is no limit to the significance that might be read into it"), 474 and especially, 479 ("…the historian…should realize the impossibility of ever drawing an exact line between the elements which signify and those which do not. Art is always open to afterthoughts, and if they happen to fit we can never tell how far they were part of the original intention").

[108] Oosten, *Magic and Reason*, 98. Obvious examples in our own culture are the issues concerning contraception, abortion and euthanasia, especially in the different religious denominations.

[109] One should think for Egypt of the "harper's songs" on p. 68, n. 10.

[110] Oosten, o.c., 91; cf. also p. 58 with n. 66. Of course, "How the world is described" is an alternative formulation to how it is classified, cf. p. 25-26.

In conclusion: forms of life need not be consistent or subordinate to exact regularity. There is room for *personal* choice for alternatives and they are thus, inherently, not static but dynamic.[111] All this agrees with the strong expression of choice as observed in the discussion of the structure of the iconographic selection process on p. 51ff, 58.

[111] This fully concurs with Wilson, *Funeral Services*, 218, who, asking the question: "…who or what was the dead noble of the Old Kingdom?" answers it by: "In other words he has his own personality" after taking into account the alternating association of the tomb owner with Osiris, Anubis, the "great god", together with the modest role of the king in funerary context. Kober, *Certainties*, 417-420, and Stern *Wittgenstein*, 114 ("it is a matter of *my* deciding to apply it [a rule, RvW] here"), 190-192 discuss this point as well.

...*Ein Ideal der Genauigkeit ist nicht vorgesehen; wir wissen nicht, was wir uns darunter vorstellen sollen – es sei denn, du selbst setzt fest was so genannt werden soll.*

No single *ideal of exactness has been laid down; we do not know what we should be supposed to imagine under this head – unless you yourself lay down what is to be so called...*

Wittgenstein, Philosophische Untersuchungen, 88

And here,..., an initial mistake in the category to which the work belongs, or worse still, ignorance of possible categories will lead the most ingenious interpreter astray.

Gombrich, *Limits*, 463

4.4. From Theory To Practice

The argument on the preceding pages, which places a strong accent especially on the problems and complex aspects that are connected to any attempt to (re)construct and understand the ancient Egyptian form of life from *ours*, has not been set up to leave the study of elite tombs from a religious or any other perspective to its own devices in disorganization. The nub lies in Künstle's reproach to Early Christian art history which should not apply to the Egyptological study of those tombs: "Nichts hat die christliche Kunstwissenschaft so sehr in Misskredit gebracht als die Sucht, aus allen figürlichen Darstellungen tiefsinnige Gedanken herauszulesen".[112]

Therefore, in the approach taken by the Leiden research, the notion "key role" (cf. p. 90, n. 110) that is played by a concept, idea or representation takes a central position. This implies, after all, their importance to the funerary individual, the tomb owner that is. The *degree* of importance is discovered by observing the frequency (cf. p. 58-59) and/or intensity with which he expresses himself in word and/or depiction – one should remember the case of wooden ship building and travelling.[113] What we are actually doing in our analyses is performing a very meticulous count and making a comparison from (minute) details to larger sub- and main themes. It will now be obvious that what we choose (that is, in first instance classify) and what we count, is dependent on the etic or external approach. In contrast, the primary, quantitative results, are objective and, so, were equally valid for an ancient Egyptian as they are for us. A good example is the analysis of "fishing with the seine" (figs. 3, 9-10) by a student member of the LMP.[114]

To the surprise of everyone only 363 recognizable fishes appeared to be represented in the nets, of which 259 are surely identifiable as a particular species.[115] Out of a total of then 273 tombs, this means hardly *one* fish of a recognizable

[112] Idem, *Symbolik*, 77.

[113] See p. 58, 72. Other examples to do with fowling consist of the eleven cases of a tree net (among others in the chapels of Hetepherakhty in Leiden and Neferirtenef in Brussels), the two cases of a swing trap and the unique case of the catching of quails; aviaries, or rather poultry farms also occur only eleven times, cf. Herb, *BiOr*, 652 (the book reviewed by Herb does not include the tomb of Hesi, published by Kanawati in 1999, so he counts ten, instead of eleven cases). Van Elsbergen, *Fischerei*, 9, mentions the same method for establishing the order of importance.

[114] The data used here are taken from the unpublished preliminary paper of Peter Missler (M.A. in Egyptology) written in 1991: *Both fishing and Foul. Rapportage Mastaba-werkgroep. Visvangstscène met sleepnet* [*Both fishing and Foul. Report Mastaba seminar. Fishing scenes with the seine*]. For the sake of convenience the report's original numbers are kept, although at present the total number of tombs has increased to 336 and of the particular scene to fifty-eight incidences in fifty-six tombs (cf. also Van Elsbergen, *Fischerei*, 9-23, 58-60) for the Memphite area, resulting in a presence percentage of still only 17 per cent.

[115] During a series of guest lectures about the present topic at Louvain in 1993, the author conducted an inquiry among twenty advanced students. While seeing a slide of an example and

species per tomb. However, at the time, there were only forty-four tombs with this scene, immediately bringing the average up to six per tomb. These tombs represent only 16 per cent of the total. The obvious conclusion is that the scene was apparently not compellingly mandatory for the (posthumous) ontological status or well-being of the (deceased) tomb owner. Meticulous counting of all sub- and main themes will logically give indications of the degree of importance of particular scenes to the ancient Egyptians themselves. In other words, such percentages are the graduator of the individual freedom common to each tomb owner and/or his artist(s)[116] and they no longer have solely an *etic* value, for the *Egyptians* made the choice.[117] We just count. This means that, actually, there is no *fundamental* chasm between the quantitative ([our] counting) and the qualitative ([their] choosing). So, at least, a partial transition can take place from an etic phrasing of a question and method of analysis to an emic answer and synthesis, as was noticed before on p. 49 (of course, supported as much as possible by textual evidence).

This conclusion is not invalidated by the fact that the majority of scenes are best preserved on the lower part of the walls of the usually partly ruined tomb buildings, and that the numbers for the (sub)-themes of these areas are consequently more reliable than for those occurring, on average, on the upper part, such as horticulture. This is easy to see because in tombs that have been more or less completely preserved, the distribution of (sub)-themes on the higher part of the walls is equally varied as on the rest, and consequently results in relative low percentages of individual (sub)-themes. This makes it highly unlikely that in the indeed badly damaged tombs, a very limited number of (sub)-themes (thus sharply raising their individual frequency percentages) should be projected there by us, for no obvious reason.

Depictions of the tomb owner, usually seated behind an offering table, with titles and name are, by definition, necessary to identify an elite tomb and define its semantic base.[118] In addition, only the main theme "offerings", subdivided

being told that the scene does not occur in every tomb of a total of around 270, they were asked to estimate in round figures the total number of fish in the scenes with the seine. The results were the following: 300 (1), 500 (2), 600 (1), 750 (1), 1000 (2), 1300 (1), 1600 (1), 2500 (1), 2600 (1), 3000 (4!), 3600 (1), 3696 sic (1), 5000 (2), 10000 (1). In my view, the explanation for these high (>2500: 11x) numbers lies in the fact that in Egyptological literature the same examples with very many well-preserved details (like our fig. 10) are most frequently reproduced.

[116] Although, ultimately, the patron had to accept the execution of a certain scene, one should not rule out or underestimate the potential initiative and/or influence of the artist. Cf. also Gombrich's remark on this in *Limits*, 467: "It is often implied that the Renaissance programme paid no heed to the artist's creative bent, but this is not necessarily true. The repertory from which to choose was so rich and varied that the final choice could easily be adapted both to the demands of decorum and the preferences of the artist".

[117] Cf. pp. 35ff.

[118] It should be realized that the "funerary meal" belongs to the oldest and most universal depictions of the funerary subject in ancient Egypt, see *LÄ*, VI, 677-679, s.v. "Totenmahl"; 711-726, s.v.

into several sub-themes, with or without explicatory texts, appears to be one hundred per cent present,[119] revealing that apparently no single deceased could permit himself to omit this theme. Hence, it was indispensable to cultic purposes. All other (sub)-themes could be chosen freely. Standing still by this fact for a moment, it is highly unlikely given the multitude of representations that the meaning of the iconographic programmes, their function and references to (possibly different spheres of) existence were uniform to the ancient Egyptian. Only in the representations of offerings, essentially the primary food supply without which no (earthly) life is possible, did these three aspects apparently coincide completely for *all* tomb owners, namely in guaranteeing sufficient food for the preservation of the "ka", the vegetative aspect of both the living and deceased human being.[120]

Of course, only the texts of the purveyors of the culture themselves can reveal to us more or less unambiguous emic aspects,[121] hence they have to be meticulously included in the iconographic analysis.[122] The frequency and formal development indicate the importance the Egyptian attached to these texts. If funerary texts and/or representations seem to possess (a) hidden meaning(s) but defy an adequate (unambiguous) interpretation, only other texts from outside can give decisive answers to the most likely *Egyptian* meaning. For as far as these are lacking, the Egyptologist has to refrain – however unsatisfactory this may be – from apodictic statements on these matters.

Returning to the fishes in the net: the previously mentioned 259 fish that could be surely identified represent fourteen species,[123] or 18.5 fishes per species. The fact that the species of *mugil* or grey occurs forty-nine times, 18.9 per cent, is not the most revealing. However, its distribution in Giza versus Saqqara in a ratio of 6.1 per cent:83,7 per cent or 1:13.7, surely is. Even by taking into consideration the greater degree of damage at Giza, it can be no coincidence. This objective fact demonstrates irrefutably a difference between Giza and Saqqara. The statistical significance of this distinction is found here by means of a *detail* in a far larger whole, a significance that is found less convincingly by

"Toter am Opfertisch". It is remarkable that not a trace of any food does occur on the stelae of either the Early Dynastic royal or their subsidiary tombs at Abydos; cf. o.c., 713.

[119] Bárta, *Abusir V*, 114-115, figs. 3.22 has removed doubt about the situation with respect to the tomb of Fetekti at Abu Sir (n. 155 of the Dutch edition).

[120] Cf. *LÄ*, III, 275-282, s.v. "Ka"; Kanawati, *Living*, 223; Assmann, *Tod*, esp. 131-139. For the sometimes speculative ideas on the *ka* in the specific context of the Old Kingdom private tombs, cf. now Bolshakov, *Double*, 123-297.

[121] Cf. Robins, *Problems*, 53. For an excellent example from the Renaissance, see Gombrich, *Limits*, 468-472.

[122] For some preliminary results concerning scenes of dance and music, see Van Walsem, *Mastaba Project*, 152-154. An example of an extensive statistical analysis of text material is, Barta, *Komparative Untersuchungen*, 104-144.

[123] In the enquiry mentioned in n. 115 the participants were asked to indicate how many different species of fish might occur in the scenes under investigation. The following answers were given: 4 (1), 6 (2), 7 (1), 9 (1), 10 (2), 11 (1), 12 (1), 14 (2), 15 (1), 18 (2), 20 (2), 27 (2), 30 (3).

comparing the distribution of the complete scene between Giza and Saqqara. In that case it is in the ratio of 1:2. Statistically significant distinctions between Giza and Saqqara have also been detected by other sub-researches of the LMP.[124] Harpur too observes a difference several times and it is found in the detailed studies of fishing and fighting boatmen as well as in the sub-theme of the handing a lotus to the tomb owner by his son.[125] Only the Egyptians themselves might answer the exact why and wherefore of this divergence.

The great variation of species in the seine in the elite tombs is in sharp contrast for instance to the remains of the so-called "Jahreszeitenreliefs" from the sun temple of King Niuserre of the 5th dynasty. Here one finds only greys, not only in the seine, but also elsewhere.[126] Apparently, the intentions at this point were different to these in the elite tombs where an "encyclopaedic" inventory of common fish in the Nile seems to be a very likely explanation, although confirmatory texts are lacking. The strongly symmetrical and hence rather unnatural composition contrasted with the realistic reproduction of fish in the net in several tombs[127] is strongly reminiscent of the still-life paintings of flowers in the Netherlands, in vogue around 1600. A description of such a still-life painted by Bosschaert (1573-1631) by Fuchs[128] is worthwhile quoting: "The near symmetry of the composition reveals a formalism which is Mannerist in feeling…To a Mannerist taste such mysterious artefacts of Nature, evidence of the Creator as artist, were of special interest. Actually one can doubt the realist "intent"…if one examines the flowers closely: they bloom at different times. The bouquet, then, is an aesthetic construction, composed from illustrations in scientific flower-books rather than from actual observation… All natural beauty, however, will eventually decay: this sentiment of transience is part[129] of the picture's meaning". Like the bouquets, the fish depicted

[124] For instance in the preliminary analyses of Van Walsem, *Mastaba Project*, 147ff; J.D. Wieringa: *Graanoogst. Onderzoeksverslag van de graanmaaiscènes in Oude-Rijks mastaba's van het Memphitische gebied in het kader van het Leidse Mastabaproject (Grain Harvest. Research Report of the Scenes of Mowing Grain in Old Kingdom Mastabas of the Memphite Area in the Frame of the Leiden Mastaba Project)* 1994 (unpubl.), passim, and 39; id., *Akkerbouwscènes in Ouderijks mastaba's van het Memphitische gebied. Inventarisatie & vergelijkende studies (Agricultural Scenes in Old Kingdom Mastabas of the Memphite Area. Inventory and Comparative Studies)*, 1995 (unpubl. MA thesis), passim, and 126. A full discussion of this issue based on all the preliminary papers and MA theses prepared so far (for a complete list of the latter, see Appendix A) falls outside the scope of the present study.

[125] See, for instance, *Decoration*, 44, 47, 53, 54, 55, 56, 57 etc; Van Elsbergen, *Fischerei*, 58-60 (G:S = 21:36 ≈ 3:5), 74 (S:G = 6:24 = 1:4), 86 (G:S = 4:20 = 1:5), 107-109 (G:S = 17:32 ≈ 1:2), 124 (G:S = 0:7); Herb, *Wettkampf*, 17, 22 (G:S = 9:26 ≈ 1:3); Fitzenreiter, *Grabdekoration*, 117-118 (G:S = 0:18).

[126] Edel, Wenig, *Jahreszeitenreliefs*, e.g., pls. 1, 13-16, 22.

[127] Cf., e.g. Moussa, Altenmüller, *Nianchchnum*, fig. 12 = our fig. 3, where in a seine there are two "layers" of fish, one fish is swimming in one direction and the other in the opposite; note also the two fish swimming upwards in the triangular curving sides of the seine.

[128] Fuchs, *Painting*, 109, 110, fig. 85.

[129] Note that Fuchs does not consider this as *the* (single and) complete meaning.

would never have been caught all together in *one* place in any one seine, and certainly not in pairs as regularly represented. Whatever its possibly symbolic meaning may have been, the representations are objective enough to identify unambiguously real species. We cannot make any *certain* categorical statements beyond this. Leaving out any speculative allegorical interpretations, the realistic conclusions in the publications of Van Elsbergen, Faltings and Herb, are in line with this.[130]

Although indisputably rooted in (a segment of) religion, a very large freedom appears to have existed alongside the (cultic) indispensable representations. This is not only expressed in the variation and size of the exchangeable main and sub-themes, but also in the tomb plans which have never been standardized to simple (figs. 5-7) or complex (fig. 8).[131] Representations that are unique or almost unique have a very special significance, such as the alleged circumcision scene in the tomb of Anhkmahor,[132] the scenes stressing the close emotional relationship between the two – it should be underlined – married tomb owners, embracing each other in the tomb of the "Two Brothers",[133] the scene of Mereruka and his harp-playing wife on a bed,[134] and, finally, the scene of a series of wailing women among whom some are pregnant, again in the tomb of Ankhmahor.[135] Such cases suggest at least a certain independence in the iconographic programme that was previously considered socially acceptable and reveal a demonstration of individuality.[136]

Although they are exceptions, they fit in excellently and are exponents of the form(s) of life of an elite. For, it were the elite and no one else, as primary holders and creators of the officially and commonly accepted norms and forms, who formed the first body that was able to formulate *and* reform the (previously) valid rules,[137] thereby guaranteeing, and indeed simultaneously themselves

[130] *Fischerei*, 125-128; *Keramik*, 287-290; *Wettkampf*, 421-431.

[131] It is essential to exercise extreme caution in the interpretation of rooms in complex tombs as exposed by Brinks in *LÄ*, III, 1214-1231, s.v. "Mastaba". Harpur, *Decoration*, 108-110, correctly draws attention to this. The architectonic freedom is also very obvious in this connection.

[132] Cf. Lauer, *Saqqara*, pl. 50. For a most convincing and, in my view, definitive re-interpretation as a scene of purification, see Grunert, *Reinigungsanweisungen*. Note, however, that he ignores the recent publications by Bailey, *Circumcision*, and Spigelman, *Circumcision*.

[133] See, Moussa, Altenmüller, *Nianchchnum*, pl. 72 (= Lauer, o.c., pl. 142)-73, 90-91; plates 4-5, 46-47 and 74 prove that they were married.

[134] Lauer, o.c., pl. 36. The scene occurs only one other time in the provincial tomb of Pepi at Meir, Harpur, *Decoration*, 27,7. That, indeed, there is a question here of a certain sexual connotation seems pretty obvious, although the texts are silent, respectively missing in Mereruka's case.

[135] Lauer, o.c., pl. 54.

[136] Cf. Hodder, *Meanings*, 4, 9; Van Walsem, *Individuality* (in press). Besides this individuality of changing or extending the rules of decorum (cf. also above p. 91 with n. 111), there is the individuality of expressing individual traits in wall representations and statuary of the tomb owner, cf. Bolshakov, *Double*, 218ff., 234ff.

[137] Cf. Hodder, o.c, 9: "Thus standardisation across many types may be especially common in relation to established authority. On the other hand…a greater security felt by individuals at the centre may allow greater eccentricities and variability". The term "valid" leaves room for the

being part of, the dynamics that are indispensable to and inherent in the histori-
cal evolution of the various cultural language-games. All in all, several lan-
guage-games appear to be "stacked" or "superposed" in an elite tomb of which
the socio-economic, in the sense of status and wealth,[138] and the artistic[139]
aspects, although not delved into here, should not be underestimated. The same
holds for the complex, because the material available is riddled with lacunae.
The relationship between the iconographic programmes of royal and private
elite tombs is still very incompletely understood.[140]

The dating of individual tombs and their iconographic programmes is an
important and, in recent years, hotly debated issue.[141] A correctly ordered series
of occurrences of a particular iconographic sub-theme may not only indicate its
earliest date of appearance but also of its potential metaphorical/allegoric inter-
pretation. Under favourable data conditions, its possibly chronological elabora-
tion and fluctuating flirtation with fashion may be revealed as well.

In other words, acknowledging the different language-games and their vari-
able expressions manifesting themselves over time in architectural shape and
iconography[142] makes it untenable that only *one* monolithic,[143] all-encompassing
and logical concept and/or symbolic/allegorical interpretation of regeneration
underlies the elite tombs of the Old Kingdom. This is the answer to the question
on p. 34: "Is the elite tomb (that is not only its iconographic programme) based
on (only) one concept, and (if so), which one? Is it uniform?"

alternatives of keeping to or changing the rules, in contrast to Bolshakov's phrasing, *Double*, 81
that "...the arrangement of representations...was subject to strict rules changing over the course
of time." "Strict" implies *no* change.

[138] Understood as expressed by the physical size, respectively mass, of the tomb as an archi-
tectonic entity, the quality of the reliefs and/or paintings, the frequency of the owner's represen-
tation, his social embedding that is expressed by series of titles and the like.

[139] Understood in the sense discussed by Junge in *Sinn*, 44-49: reproduction techniques and
the different phases in style and form.

[140] See, e.g. Goedicke, *Verhältnis* and Feucht, *Fishing*.

[141] The most important recent literature on the subject is: Harpur, *Decoration*, 33-42;
Cherpion, *Hypogées* (book reviews in *OLZ*, 86 (1991), 370-376 [E. Martin-Pardey]; *DE*, 20 (1991),
93-100 [J. Málek]; *JEA*, 78 (1992), 324-326 [N. Kanawati]; *JNES*, 53 (1994), 55-58 [A.M. Roth]);
Seidlmayer, *Stil und Statistik*; Bolshakov, *Double*, 47, 81-82, Baud, *Critères*; id., *Famille royale*,
5-104; Piacentini, *Scribes*, 21-33, Bárta, *Giza*, 36-74.

[142] Oster's *Bedeutungswandel*, deserves a mention here. Although he uses the difference
between Upper and Lower Egyptian funerary ideas rather rigidly as explanatory factor, he demon-
strates changes in funerary mentality convincingly using the various lines of tomb shape, iconog-
raphy and texts. More recently, Metwally, *Grabdekoration*, 171 also speaks of: "...interessante
Veränderung in der geistigen Haltung der damaligen Ägypter".

[143] Quirke, *Ma'at*, 223 notes another monolithic fallacy for Egyptian kingship by: "Mono-
lithic kingship is an Egyptological, and perhaps already a Middle Kingdom, construct that arises
out of comparisons between the Giza pyramids and virtually any other monument". Although
Fitzenreiter, *Grabdekoration*, correctly differentiates several iconographic (sub)-themes more or
less in accordance with our language-game model (although he does not use the term), he is
"monolithic" because he still tries to understand the entire decoration as referring to rituals, wit-
ness the full title of his article.

Was wir liefern, sind eigentlich Bemerkungen zur Naturgeschichte des Menschen aber nicht kuriöse Beiträge, sondern Feststellungen, an denen niemand gezweifelt hat, und die dem Bemerktwerden nur entgehen, weil sie ständig vor unsern Augen sind.

What we are supplying are really remarks on the natural history of human beings; we are not contributing curiosities however, but observations which no one has doubted, but which have escaped remark only because they are always before our eyes.

Wittgenstein, Philosophische Untersuchungen, 415

"I know about the little spaniel. I know what the weather was like in Massachusetts on Wednesday March 7th 1620 (cold but fair, with the wind in the east). I know the names of those who died that winter and of those who did not. I know what you ate and drank, how you furnished your houses, which of you were men of conscience and application and which were not.
And I know, also, nothing. Because I cannot shed my skin and put on yours, cannot strip my mind of its knowledge and its prejudices, cannot look cleanly at the world with the eyes of a child, am as imprisoned by my time as you were by yours".

P. Lively, *Moon Tiger*, 31

5. CONCLUSIONS

Having come to this point, the preceding argument can be summarized as follows. A meticulous iconographic description and analysis based on Panofsky's approach, in combination with a well-defined and statistically underpinned classification with (especially with reference to the latter) an open eye for the "emic"-"etic" issue, methodologically and theoretically furnishes the best guarantees for discerning the (sub-) language-games possibly present plus delineating, their use, their boundaries and their individual, respectively collective aspects as contents of complex sign systems. In this way one also contributes to cognitive archaeology, cognitive religious studies that enjoy an increasing interest and, eventually to cognitive sciences in general.[1]

For the elite tomb as an entity it means that, in its primary *function*, it obviously belongs to a funerary-religious language-game. By its very nature, it is a material expression of humans of their interaction with existence, specifically in relation to the uncontrollable phenomenon of death, which is dealt with religious aspects in all cultures. It concerns an expression that manifests itself on behalf of the funerary individual in the form of cult in the widest sense of the word.[2]

A decidedly primary religious *content*, confirmed by texts (offering formulae with references to gods such as Osiris and Anubis and others), ineluctably occurs in the scenes of the tomb owner in the context of the offering cult/ritual. The remaining scenes *may* have had such content as well, but we cannot (always) demonstrate it directly and unambiguously. Therefore, scientifically the best thing we can do is to interpret these scenes, until the contrary has been proven, as referring to *conceivably* (not objectively *historically*) real situations in the pluralistic existence of the tomb owner as member of the elite. This is expressed in several, mainly pictorial language-games,[3] where a large, if not the largest part of the iconography is a reflection of a sophisticated ideology of

[1] Cf. Renfrew, Bahn, *Archaeology*, 339-370; Renfrew, Zubrow, *Ancient Mind*. For cognitive religious studies, cf., e.g. Boyer, *Explaining* and the collection of papers including Englund's *Gods*. The relationship individuality-collectivity concerns the field of cultural psychology, cf. Matsumoto *Culture and Psychology*, 42-47, and index 564. For (cognitive) archaeology and cultural psychology as acknowledged "members" of the cognitive sciences, see, Wilson, Keil, *Cognitive Sciences*, 122-124, s.v. "cognitive archaeology"; 211-213, s.v. "cultural psychology".

[2] One should realize that, in first instance, in Latin the word means "cultivation", "care", from which "reverence", "adoration" have been derived, Lewis, Short, *Latin Dictionary*, 488.

[3] Although accompanying texts may form an artistic and semantic complementary unity with the pure depictions, the pictorial dominance is proved by the frequent absence of (any) captions; cf. p. 82, n. 74.

status that was grounded, at least for an important part, in the concept of Ma'at (= "social and cosmic order/harmony/ balance") according to the norms of the Old Kingdom.[4] For the time being, it seems highly likely, again until the opposite has been convincingly demonstrated, this "art" of the elite tombs was not primarily or exclusively a magical means for the continuation of the "here and now" into the "Hereafter". It seems instead to be a means to continue and actualize, via cult and thus memory, the deceased's social embedding,[5] again in the widest sense of the word,[6] in the "here".

It is evident that the method followed rather mercilessly exposes the limits of our understanding of what a complex artefact as an elite tomb exactly is and represents. Also the "Ma'at interpretation" given above, at present, cannot be substantiated beyond doubt as *the* "dominant level" or "core meaning"[7] of the iconographic programmes of this category of artefacts. So, I cannot but endorse the latter part of Baines' dictum (cf. motto p. xii) that we are still dealing with "...*the essentially unsolved general problem of the purpose of Old Kingdom tomb decoration.*" All this unavoidably entails an interpretative modesty, of course unsought but still necessary, concerning our attempts to understand the ancient Egyptian as correctly as possible.

This methodology and its resulting modesty are in full harmony with the observations of the former Leiden professor of Art History, Boschloo, in his inaugural address: "In order to get, at least, well underway, it is necessary to recognise this many-sidedness of every work of art and to study as many as possible of the various factors that have contributed to its creation. This demands an interpretation on different levels. One single method, clearly defined yet always limited, is not sufficient. Thus, I am equally against the stylistic as the iconographical, the iconological or the Marxist approach, when they are presented as all-beatific methods. It is obvious that not many are able to handle two, three or more methods equally successfully. The crux of the matter is that we are conscious of the confinement of every, one-sided approach. Studying works of arts forces [the student] to be modest".[8] This view is also propagated by Gombrich: "...the historian should also retain his humility in the face of evidence."[9]

[4] Cf. Junge, *Sinn*, 57; Assmann, *Ma'at*, 92-109; the latter postulates a change, or rather erosion of Ma'at in the New Kingdom, which is called controversial in *OEAE*, 2, 319-321, s.v. "Maat". It is noteworthy that several tomb owners were "priest of Ma'at", e.g. Hetepher-akhty, the owner of the Leiden chapel, Mohr, *Hetep-her-akhty*, 33-35. See also Strudwick, *Administration*, 178-179.

[5] Cf. Junge, o.c., 57ff.

[6] One should think of Clarke's (socio-) cultural (sub)-systems as discussed on p. 68 and in n. 7.

[7] Gombrich, *Limits*, 476 uses the terms "...the dominant meaning, the intended meaning or principal purpose of the picture".

[8] Author's translation of Boschloo, *De veelzeggende toeschouwer (The Telling Spectator)*, 21.

[9] Gombrich, *Limits*, 479.

Modesty was also a virtue among the Egyptians, as appears from the "negative confession" in Book of the Dead, Spell 125 where the deceased had to answer for his sins. One of the forty-two *faux pas* not committed he thus put into words as: "I have not been puffed up".[10] Striving for this is a timeless commission – like art – and hence the ancient Egyptian religious and the modern scientific language-games are ultimately connected on equal terms, irrespective of anything else.

[10] Allen, *Book of the Dead*, 99,39.

APPENDIX A

List of (unpublished) MA-theses of the Leiden Mastaba Project.

- H.J. Top, *Van etnoarcheologisch onderzoek tot grafreliëfs; de vele gezichten en problemen van de vervaardiging van stenen vaatwerk (From Ethnoarchaeological Research to Tomb reliefs; the Many Faces and Problems of the Production of Stone Vessels)*, Leiden 2003.
- H.Oost, *A Numerical Approach to Palanquin-scenes in the Old Kingdom Court Cemetery Mastaba Tombs. From Theory to Practical Results*, Leiden 1999.
- M.M. Vugts, *De wijnbouw in de privé-graven van het Oude Egypte (Viniculture in the Private Tombs of Ancient Egypt)*, Leiden 1999
- R. Kruit, *Offerscènes. In het bijzonder offertafelscènes in graven uit de 4e dynastie te Gizeh en Sakkara (Offering scenes. In Particular Offering Table Scenes in Tombs of the 4th Dynasty at Gizeh and Saqqara)*, Leiden 1998.
- H.S.A. Douwes, *Voer voor overlevenden. Een numerieke benadering van de veeteelt in de decoraties van de Ouderijks elitegraven. In het bijzonder van de afbeeldingen van het dekken, kalven en melken (Food for Survivers. A Numerical Approach of Cattle Breeding in the Decoration of Old Kingdom Elite Tombs. In Particular the Scenes of Copulation, Calving and Milking)*, Leiden, 1997.
- J.D. Wieringa, *Akkerbouwscènes in Ouderijks mastaba's van het Memphitische gebied. Inventarisatie & vergelijkende studies (Agricultural Scenes in Old Kingdom Mastabas of the Memphite Area. Inventory and Comparative Studies)*, Leiden 1995.
- H. Nouwens, *Ezels in de graanbouw. Een analyse van de afbeeldingen in de Oude-rijks mastaba's uit de Memphitische regio (Donkeys in the Cultivation of Grain. An Analysis of the Representations in the Old Kingdom Mastabas of the Memphite Area)*, Leiden 1995.
- B.A.H.M. Lok-Knap, *Een zoektocht naar weefsters in het oude Rijk...en zij weefden nog lang en gelukkig (Searching Weavers in the Old Kingdom...They Weaved Long and Happily*, Leiden 1994.

BIBLIOGRAPHY

Adams, Adams, *Typology*: W.Y. Adams, E.W. Adams, *Archaeological Typology and Practical Reality. A Dialectical Approach to Artifact Classification and Sorting* (Cambridge, 1991).

Allen, Turvey, *Wittgenstein*: R. Allen, M. Turvey (eds.), *Wittgenstein, Theory and Arts* (London, New York, 2001).

Allen, *Book of the Dead*: T.G. Allen, *The Book of the Dead or Going Forth by Day. Ideas of the Ancient Egyptians Concerning the Hereafter as Expressed by Their Own Terms* (Chicago, 1974).

Altenmüller, *Isis*: H. Altenmüller, 'Zum Ursprung von Isis und Nephthys', *SAK*, 27 (1999), 1-26.

Idem, *Himmelsaufstieg*:, id., 'Der Himmelsaufstieg des Grabherrn. Zu den Szenen des *zšs-w3d* in den Gräbern des Alten Reiches', *SAK*, 30 (2002), 1-42.

Idem, *Harfnerlieder*: id., 'Zur Bedeutung der Harfnerlieder des Alten Reiches', *SAK*, 6 (1978), 1-24.

Anscombe, see Wittgenstein, *Philosophische Untersuchungen*.

Assmann, *Sprachbezug*: J. Assmann, 'Sprachbezug und Weltbezug der Hieroglyphenschrift', in: id., *Stein und Zeit*, 76-92.

Idem, *Entdeckung der Vergangenheit*: id., 'Die Entdeckung der Vergangenheit. Innovation und Restauration in der ägyptischen Literaturgeschichte', in: id., *Stein und Zeit*, 303-313.

Idem, *Ma'at*: id., *Ma'at. Gerechtigkeit und Unsterblichkeit im alten Ägypten* (München, 1990).

Idem, *Stein und Zeit*: id., *Stein und Zeit. Mensch und Gesellschaft im alten Ägypten* (München, 1991).

Idem, *Hierotaxis*: id., 'Hierotaxis. Textkonstruktion und Bildkomposition in den altägyptischen Kunst und Literatur', in: J. Osing, G. Dreyer (eds.), *Form und Mass. Beiträge zur Literatur, Sprache und Kunst des Alten Ägypten* (Wiesbaden, 1987), 18-42.

Idem, *Sinngeschichte*: id., *Ägypten. Eine Sinngeschichte* (München, 1996).

Idem, *Tod*: id., *Tod und Jenseits im Alten Ägypten* (München, 2001).

Assman, Burkhard, *5000 Jahre Ägypten*: J. Assmann, G. Burkard (eds.), *5000 Jahre Ägypten. Genese und Permanenz pharaonischer Kunst* (Heidelberg, 1983).

Assmann, Burkard, Davies, *Problems and Priorities*: J. Assmann, G. Burkard, V. Davies (eds.), *Problems and Priorities in Egyptian Archaeology*, (London & New York, 1987).

BACE: *Bulletin of the Australian Centre for Egyptology*, Sydney.

Bailey, *Circumcision*: 'The Circumcision Scene in the Tomb of Ankhmahor: the First Record of Emergency Surgery?', *BACE*, 8 (1997), 91-100.

Baines, *Ancient Egyptian Art*: J. Baines, 'On the Status and Purpose of Ancient Egyptian Art, *CAJ* 4:1 (1994), 67-94.

Idem, *Narrative Biographies*: J. Baines, 'Forerunners of Narrative Biographies, in: A. Leahy, J. Tait (eds.), *Studies*, 23-37.

Balandier, *Le désordre*: G. Balandier, *Le désordre. Eloge du mouvement* (Paris, 1988).

Barta, *Untersuchungen*: W. Barta, *Komparative Untersuchungen zu vier Unterweltsbüchern* (München, 1989).

Bárta, *Abusir V*: M. Bárta, *Abusir V. The Cemeteries at Abusir South I* (Prague, 2001).

Idem, *Giza*: M.Bárta, *Giza in der 4. Dynastie. Die Baugeschichte und Belegung einer Nekropole des Alten Reiches. Band I: Die Mastabas der Kernfriedhöfe und die Felsgräber* (Wien, 2005)

Baud, *Critères*: M. Baud 'À propos des critères iconographiques établis par Nadine Cherpion' in Grimal (ed.) *Datation*, 31-95.

Idem, *Famille royale*: id., *Famille royale et pouvoir sous l'Ancien Empire égyptien*, (Le Caire, 1999).

Bolshakov, *Double*: A.O. Bolshakov, *Man and his Double in Egyptian Ideology of the Old Kingdom* (Wiesbaden, 1997).

Boschloo, *The Telling Spectator*: A.W.A. Boschloo, *The Telling Spectator. Address Pronounced at the Accession to the Duties of Ordinary Professor in the History of Art* (author's translation of id.: *De veelzeggende toeschouwer. Rede uitgesproken bij de aanvaarding van het ambt van gewoon hoogleraar in de kunstgeschiedenis* (Leiden, 1976).

Boyer, *Explaining*: P. Boyer, 'Explaining Religious Ideas: Elements of a Cognitive Approach', in: *Numen*, 39 (1992), 26-57.

Brewer, Friedman, *Fish*: D.J. Brewer, R.F. Friedman, *Fish and Fishing in Ancient Egypt* (Warminster, 1989).

Brunner-Traut, *Ägypter*: E. Brunner-Traut, *Die alten Ägypter. Verborgenes Leben unter Pharaonen* (Stuttgart, Berlin, Köln, Mainz, 1981).

Buchberger, *Sexualität*: H. Buchberger, 'Sexualität und Harfenspiel — Notizen zur "sexuellen" Konnotation der altägyptischen Ikonographie', *GM* 66 (1983), 11-43.

Idem, *Transformation*: id., *Transformation und Transformat. Sargtextstudien I* (Wiesbaden, 1993).

Idem, *Harfnerlied*: id., 'Das Harfnerlied im Grab des *Kȝ(=i)-m-ʿnḫ*', in: Kessler, Schulz (eds.), *Winfried Barta*, 93-123.

CAJ: *Cambridge Archaeological Journal*, Cambridge.

Cherpion, *Mastabas*: N. Cherpion, *Mastabas et hypogées d'Ancien Empire. Le problème de la datation* (Bruxelles, 1989).

Chisholm, *Theory*: R.M. Chisholm, *Theory of Knowledge Second edition* (Englewood Cliffs, 1977).

Clarke, *Archaeology*: D.L. Clarke, *Analytical Archaeology*, (London, 1978).

Clarysse, *Egyptian Religion*: W. Clarysse et al. (eds.), *Egyptian Religion. The Last Thousand Years, Part II. Studies Dedicated to the Memory of Jan Quaegebeur* (Leuven, 1998).

Dasen, *Dwarfs*: V. Dasen, *Dwarfs in Ancient Egypt and Greece* (Oxford, 1993).

Davies, *Ptahhetep*: N. de G. Davies, *The Mastaba of Ptahhetep and Akhethetep at Saqqara* (London, 1900).

DE: *Discussions in Egyptology*, Oxford.

Dijk, van, *Essays*: J. van Dijk (ed.), *Essays on Ancient Egypt in Honour of Herman te Velde* (Groningen, 1997).

Dominicus, *Gesten*: B. Dominicus, *Gesten und Gebärde in Darstellungen des Alten und Mittleren Reiches* (Heidelberg, 1994).

Edel, *Grammatik*: E. Edel, *Altägyptische Grammatik* (Rome, 1955-1964).

Edel, Wenig, *Jahreszeitenreliefs*: E. Edel, S. Wenig, *Die Jahreszeitenreliefs aus dem Sonnenheiligtum des Königs Ne-User-Re* (Berlin, 1974).

Elsbergen, M.J. van, *Fischerei*: M.J. van Elsbergen, *Fischerei im alten Ägypten. Untersduchungen zu den Fischfangdarstellungen in den Gräbern der 4. bis 6. Dynastie* (Berlin, 1997).

Englund, *Gods*: G. Englund, 'Gods as a Frame of Reference, on Thinking and Concepts of Thought in Ancient Egypt', in: G. Englund (ed.), *Religion*, 7-28.

Idem, *Religion*: G. Englund (ed.), *The Religion of the Ancient Egyptians, Cognitive Structures and Popular Expressions* (Uppsala, 1987).

Eyre, *Proceedings*: C. Eyre (ed.), *Proceedings of the Seventh International Congress of Egyptologists. Cambridge, 3-9 September 1995* (Leuven, 1998).

Faltings, *Lebensmittelproduktion*: D. Faltings, *Die Keramik der Lebensmittelproduktion im Alten Reich. Ikonographie und Archäologie eines Gebrauchsartikels* (Heidelberg, 1998).

Feucht, *Fishing:* E. Feucht, 'Fishing and Fowling with the Spear and the Throw-stick Reconsidered', in: U. Luft (ed.), *Intellectual Heritage*, 157-169.

Finnestad, *Religion*: R.B. Finnestad, 'Religion as a Cultural Phenomenon', in: Englund (ed.), *Religion*, 73-76.

Fischer-Elfert, *Hierotaxis*: H.-W, Fischer-Elfert, 'Hierotaxis auf dem Markte — Komposition, Kohärenz und Lesefolge der Marktszenen im Grabe des Nianchchnum und Chnumhotep', *SAK*, 28 (2000), 67-92.

Fitzenreiter, *Grabdekoration*: M. Fitzenreiter, 'Grabdekoration und die Interpretation funerärer Rituale im Alten Reich' in: H.O. Willems (ed.), *Social Aspects*, 67-140.

Idem, *Totenverehrung*: id., 'Totenverehrung und soziale Repräsentation im thebanischen Beamtengrab der 18. Dynastie', *SAK,* 22 (1995), 95-143.

Fletcher, Lock, *Digging numbers*: M. Fletcher, G.R. Lock, *Digging Numbers. Elementary Statistics for Archaeologists* (Oxford, 1994).

Frandsen, *Categorization and Metaphorical Structuring*: P.J. Frandsen 'On Categorization and Metaphorical Structuring: Some Remarks on Egyptian Art and Language', *CAJ* 7:1 (1997), 71-104.

Fuchs, *Painting*: R.H. Fuchs, *Dutch Painting* (London, 1978).

Gamer-Wallert, *Fische*: I. Gamer-Wallert, *Fische und Fischkulte im alten Ägypten* (Wiesbaden, 1970).

Gardiner, *EG*: A.H. Gardiner, *Egyptian Grammar. Being an Introduction to the Study of Hieroglyphs* (Oxford, 1957).

GM: *Göttinger Miszellen*, Göttingen.

Goedicke, *Verhältnis*: H. Goedicke, 'Das Verhältnis zwischen königlichen und privaten Darstellungen im Alten Reich', *MDAIK*, 15 (1957), 57-67.

Gombrich, *Norm*: E.H. Gombrich, *Norm and Form. Studies in the Art of the Renaissance* (London, 1971).

Idem, *Art and Illusion*: id., *Art and Illusion: a Study in the Psychology of Pictorial Representation*, 5th ed. (London, 1995).

Idem, *Cultural History*: id., 'In Search of Cultural History', in: R. Woodfield (ed.), *The Essential Gombrich* (London, 1996), 381-399.

Idem, *Limits*: 'Aims and Limits of Iconology', in: R. Woodfield (ed.), *The Essential Gombrich* (London, 1996), 457-484.

Idem, *Steinberg*: id., 'The Wit of Saul Steinberg', in: R. Woodfield (ed.), *The Essential Gombrich* (London, 1996), 539-545.

Idem, *Uses of images*:, id., *The Uses of Images. Studies in the Social Function of Art and Visual Communication* (London, 1999).

Gough, *Christians*: M. Gough, *The Early Christians* (London, 1961) (Dutch edition, id., *Christenen*: M. Gough, *De eerste Christenen*, (Zeist, 1963).

Gregory, Zangwill, *Mind*: R.L. Gregory, O.L. Zangwill (eds.), *The Oxford Companion to the Mind* (Oxford, New York, 1997).

Grimal, *Datation*: N. Grimal (ed.), *Les critères de datation stylistiques à l'Ancien Empire* (Le Caire, 1998).

Grunert, *Reinigungsanweisungen*: S. Grunert, 'Nicht nur sauber, sondern rein – Rituelle Reinigungsanweisungen aus dem Grab des Anchmahor in Saqqara' *SAK* 30 (2002), 137-151.

Hagberg, *Art as Language*: G.L. Hagberg, *Art as Language. Wittgenstein, Meaning and Aesthetic Theory* (Ithaca, 1995).

Hamlyn, *Philosophy*: D. W. Hamlyn, *A History of Western Philosophy* (Harmondsworth, 1987) (Dutch translation: id., *Westerse filosofie. Een geschiedenis van het denken* (Utrecht, 1988).

Hannig, *Wörterbuch, I*: R. Hannig, *Ägyptisches Wörterbuch, I, Altes Reich und Erste Zwischenzeit* (Mainz am Rhein, 2003).

Harpur, *Decoration*, Y. Harpur, *Decoration in Egyptian Tombs of the Old Kingdom* (London, New York, 1987).

Idem, *Maidum*: id., *The Tombs of Nefermaat and Rahotep at Maidum. Discovery, Destruction and Reconstruction* (Oxford, 2001).

Herb, *BiOr*; M. Herb, review of: O. Mahmoud, Die wirtschaftliche Bedeutung der Vögel im Alten Reich, in: Bibliotheca Orientalis, 50, 5/6, 1993, 643-654.

Idem, *Wettkampf*: M. Herb, *Der Wettkampf in den Marschen. Quellenkritische, naturkundliche und sporthistorische Untersuchungen zu einem altägyptischen Szenentyp* (Hildesheim, 2001).

Hermans, *Wittgenstein*: W.F. Hermans, *Wittgenstein* (Dutch) (Amsterdam, 1990).

Hill, *Prehistoric Cognition*: J.N. Hill, 'Prehistoric Cognition and the Science of Archaeology', in: C. Renfrew, E.B.W. Zubrow, *Ancient Mind*, 83-92.

Hodder, *Meanings*: I. Hodder, 'The Contextual Analysis of Symbolic Meanings', in.: idem (ed.), *The Archaeology of Contextual Meanings* (Cambridge, 1987), 1-10.

Idem, *Contextual Meanings*: id. (ed.), *The Archaeology of Contextual Meanings* (Cambridge, 1987).

Hodder, Shanks et al. (eds.): *Interpreting Archaeology*: I. Hodder, M. Shanks et al. (eds.), *Interpreting Archaeology. Finding Meaning in the Past* (London, 1997).

Holwerda, *Beschreibung*: A.E.J. Holwerda, P.A.A. Boeser, J.H. Holwerda, *Beschreibung der ägyptischen Sammlung des niederländischen Museums der Altertümer in Leiden. Die Denkmäler des Alten Reiches* (Haag, 1908).

Honderich, *Philosophy*: T. Honderich (ed.), *The Oxford Companion to Philosophy*, (Oxford, New York, 1995).

Hornung, *Der Eine*: E. Hornung, *Der Eine und die Vielen* (Darmstadt, 1973).

Hornung, Staehelin: *Skarabäen*: E. Hornung, E. Staehelin, *Skarabäen und andere Siegelamulette aus Basler Sammlungen* (Mainz, 1976).

Huizinga, *Herfsttij*: J. Huizinga, *Herfsttij der Middeleeuwen. Studie over levens- en gedachtenvorm der veertiende en vijftiende eeuw in Frankrijk en de Nederlanden* (Groningen, 1986).

Idem, *Waning*: idem (translator F. Hopman), *The Waning of the Middle Ages. A Study of the Forms of life, Thought and Art in France and the Netherlands in the XIVth and XVth Centuries* (London, 1976).

Huntington, Metcalf, *Death*: R. Huntington, P. Metcalf, *Celebrations of Death. The Anthropology of Mortuary Ritual* (Cambridge, 1992).

Janson, *History of Art*: H.W. Janson, *A History of Art. A Survey of the Visual Arts from the Dawn of History to the Present Day* (London, 1978).

JEA: *Journal of Egyptian Archaeology* (London).

JNES: *Journal of Near Eastern Studies* (Chicago).

Jones, *Titles*: D. Jones, *An Index of Ancient Egyptian Titles, Epithets and Phrases of the Old Kingdom* (Oxford, 2000).

Junge, *Sinn*: F. Junge, 'Vom Sinn der ägyptischen Kunst. Am Beispiel des Alten Reiches', in J. Assmann, G. Burkard (eds.), *5000 Jahre Ägypten*, 43-60.

Junker, *Gîza*: H. Junker, *Gîza*, 5 (Leipzig, Wien, 1941).

Kanawati, *Living*: N. Kanawati, 'The living and the dead in Old Kingdom tomb scenes', *SAK* 9 (1981), 213-225.

Idem, *JEA*: id., book review of N. Cherpion, *Mastabas et hypogées d'Ancien Empire. Le problème de la datation* (Bruxelles, 1989), *JEA*, 78 (1992), 324-326.

Kanawati, Abder-Raziq, *Hesi*: N. Kanawati, M. Abder-Raziq, *The Teti Cemetery at Saqqara, Volume V, The Tomb of Hesi* (Warminster, 1999).

Kaplony, *Methethi*: P. Kaplony, *Studien zum Grab des Methethi* (Bern, 1976).

Kaemmerling, Ikonographie: E. Kaemmerling (ed.), *Ikonographie und Ikonologie. Theorien – Entwicklung – Probleme. Bildende Kunst als Zeichensystem Band 1* (Köln, 1984).

Kemp, *Ancient Egypt*: B.J. Kemp, *Ancient Egypt. Anatomy of a Civilisation* (London, New York, 1989).

Kessler, *Bedeutung*: D. Kessler, 'Zur Bedeutung der Szenen des täglichen Lebens in den Privatgräbern (I): Die Szenen des Schiffbaues und der Schiffahrt', in: *ZÄS*, 114 (1987), 59-88.

Kessler, Schulz, *Winfried Barta*: D. Kessler, R. Schulz (eds.), *Gedenkschrift für Winfried Barta* (Frankfurt am Main, 1995).

Kitchen, *Poetry*: K.A. Kitchen, *Poetry of Ancient Egypt* (Jonsered, 1999).

Kober, *Certainties*: M. Kober, 'Certainties of a World-picture: The Epistemological Investigations of *On Certainty*', in: H. Sluga, D.G. Stern (eds.), *Wittgenstein* (Cambridge, 1996), 411-441.

Klasens, *Kunst*: A. Klasens, *Egyptische kunst uit de collectie van het Rijksmuseum van Oudheden te Leiden* (no date, no place).

Künstle *Symbolik*, K. Künstle, 'Symbolik und Ikonographie der christlichen Kunst. Zur Methodologie der christlichen Ikonographie', in: E. Kaemmerling (ed.), *Ikonographie*, 64-80.

Lakoff, *Women, Fire*: G. Lakoff, *Women, Fire, and Dangerous Things. What Categories Reveal about the Mind* (Chicago, London, 1987).

LÄ: E. Otto, W. Helck, *Lexikon der Ägyptologie* (Wiesbaden, 1975-1992).

Lauer, *Saqqara*: J.-P. Lauer, *Saqqara. The Royal Cemetery of Memphis* (London, 1976).

Leahy, Tait, *Studies*: A. Leahy, J. Tait (eds.), *Studies on Ancient Egypt in Honour of H.S. Smith* (London, 1999).

Lewis, Short, *Latin Dictionary*: C.T. Lewis, C. Short, *A Latin Dictionary* (Oxford, 1980).

Liddell, Scott, *Greek-English Lexicon*: H.G. Liddell, R. Scott, *Greek-English Lexicon* (Oxford, 1925-1940).

Liebmann, *Ikonologie*: M. Liebmann, 'Ikonologie', in: E. Kaemmerling (ed.), *Ikonographie*, 301-328.

Lively, *Moon Tiger*: P. Lively, *Moon Tiger* (London, 1988).

Luft, *Intellectual Heritage*: U. Luft (ed.), *The Intellectual Heritage of Egypt*, (Budapest, 1992).

Málek: *DE*: book review of N. Cherpion, *Mastabas et hypogées d'Ancien Empire. Le problème de la datation* (Bruxelles, 1989), *DE*, 20 (1991), 93-100.

Mariette, *Mastabas*: A. Mariette, *Les Mastabas de l'Ancien Empire* (Paris, 1889).

Martin-Pardey: *OLZ*: book review of N. Cherpion, *Mastabas et hypogées d'Ancien Empire. Le problème de la datation* (Bruxelles, 1989), *OLZ*, 86 (1991), 370-376.

Matsumoto, *Culture and Psychology*: D. Matsumoto, *Culture and Psychology. People Around the World* (Stamford, 2000).

McGinn, *Wittgenstein*: M. McGinn, *Wittgenstein and the Philosophical Investigations* (London, 1997).

MDAIK: *Mitteilungen des Deutschen Archäologischen Instituts Abteilung Kairo* (Cairo).

Metwally, *Entwicklung*: E. El-Metwally, *Entwicklung der Grabdekoration in den altägyptischen Privatgräbern. Ikonographische Analyse der Totenkultdarstellungen von der Vorgeschichte bis zum Ende der 4. Dynastie* (Wiesbaden, 1992).

Mohr, *Hetep-her-akhti*: H.T. Mohr, *The Mastaba of Hetep-her-akhti. Study of an Egyptian tomb chapel in the Museum of Antiquitie*s (Leiden, 1943).

Montet, *Scènes*: P. Montet, *Les scènes de la vie privée dans les tombeaux Égyptiens de l'Ancien Empire* (Strasbourg, 1925).

Moussa, Altenmüller, *Nianchchnum*: A. Moussa, H. Altenmüller, *Das Grab des Nianchchnum und Chnumhotep* (Mainz am Rhein, 1977).

Müller, *Gute Hirte*: D. Müller, 'Der gute Hirte, Ein Beitrag zur Geschichte ägyptischer Bildrede, *ZÄS*, 86 (1961), 126-144.

Müller, Zimmermann (eds.), *Archäologie*: J. Müller, A. Zimmermann (eds.), *Archäologie und Korrespondenzanalyse. Beispiele, Fragen, Perspektiven* (Espelkamp, 1997).

Munro, *Unas-Friedhof*: P. Munro, *Unas-Friedhof. Der Unas-Friedhof Nord-West I. Das Doppelgrab der Königinnen Nebet und Khenut* (Mainz am Rhein, 1993).

Mysliwiec, *Merefnebef Fowling*: K. Mysliwiec, 'The Merefnebef Fowling: the Scene in his Tomb', in N.Kloth et al. (eds.), *Es werde niedergelegt als Schriftstück. Festschrift für Hartwig Altenmüller zum 65. Geburtstag* (Hamburg, 2003), 291-294.

Numen: *International Review for the History of Religions* (Leiden).

O'Connor, Silverman, *Kingship*: D.O'Connor, D.P. Silverman (eds.), *Ancient Egyptian Kingship* (Leiden, 1995).

OEAE: D.B. Redford (ed.), *The Oxford Encyclopedia of Ancient Egypt*, I-III (Oxford, New York, 2001).

OLZ: *Orientalistische Literaturzeitung* (Berlin).

ONN: *Opuscula Niliaca Noviomagensia* (Nijmegen).

Oosten, *Magic and Reason*: J.J. Oosten, *Magic and Reason, an Inquiry into the Influence of Magic Modes of Thought in Our Reason-Oriented Culture* (author's translation of title of: id., *Magie en Rede, een onderzoek naar de invloed van magische denkwijzen binnen onze op het verstand georiënteerde cultuur* (Assen, 1983).

Osborne, *Art*: H. Osborne (ed.), *The Oxford Companion to Art*, (Oxford, 1970).

Oster, *Bedeutungswandel*: H. Oster, *Der Bedeutungswandel des ägyptischen Privatgrabes bis zum Ende des Alten Reiches* (no place, 1963).

Paget, Pirie, *Ptah-hetep*: R.F.E. Paget, A.A. Pirie, *The tomb of Ptah-hetep* (London, 1898).

Panofsky, *Iconography*: E. Panofsky, 'Iconography and Iconology: an Introduction to the Study of Renaissance Art', in: id., *Meaning in the Visual Arts* (Harmondsworth, 1983), 51-67.

Idem, *History of Art*: id., 'Introduction: The History of Art as a Humanistic Discipline' in: id., *Meaning in the Visual Arts* (Harmondsworth, 1983), 23-50.

Peatfield, *Cognitive Aspects*: A. Peatfield, 'Cognitive Aspects of Religious Symbolism: an Archaeologist's Perspective' [review of P. Boyer, *Cognitive Aspects of Religious Symbolism*], *CAJ*, 4,1 (1994), 149-155.

Piankoff, *Aï*: A. Piankoff, 'Les Peintures dans le Tombeau du Roi Aï', *MDAIK*, 16 (1958), 247-251.

Piacentini, *Scribes*: P. Piacentini, *Les scribes dans la société égyptienne de l'Ancien Empire, I. Les premières dynasties. Les nécropoles Memphites* (Paris, 2002).

Polz, *Excavation*: D. Polz, 'Excavation and Recording of a Theban Tomb. Some Remarks on Recording Methods', in: J. Assmann, G. Burkard, V. Davies (eds.), *Problems and Priorities*, 119-140.

Prigogine, Stengers, *Order*: I. Prigogine, I Stengers, *Order out of Chaos. The New Dialogue between Man and Nature* (Dutch edition, *Orde uit chaos. De nieuwe dialoog tussen de mens en de natuur* (Amsterdam, 1985).

Quirke, *Ma'at*: S. Quirke, 'Translating *Ma'at*', *JEA*, 80 (1994), 219-231.

Redford, *Historiography*: D.B. Redford, 'The Historiography of Ancient Egypt', in K. Weeks (ed.), *Egyptology*, 3-20.

Idem, *Kingship*: id., 'The Concept of Kingship during the Eighteenth Dynasty', in: D. O'Connor, D.P. Silverman (eds.), *Kingship*, 157-184.

Renfrew, Bahn, *Archaeology*: C. Renfrew, P. Bahn, *Archaeology. Theories Methods and Practice* (London, 1991).

Renfrew, Zubrow, *Ancient Mind*: C. Renfrew, E.B.W. Zubrow, *The Ancient Mind. Elements of Cognitive Archaeology* (Cambridge, 1995).

Richardson, *Bible*: A. Richardson, *The Bible in the Age of Science* (London, 1961) (Dutch edition: A. Richardson, Bijbel en moderne wetenschap (Utrecht, 1966)).

Ritner, *Magical Practice*: R.K. Ritner, *The Mechanics of Egyptian Magical Practice* (Chicago, 1993).

Robins, *Problems*: G. Robins, 'Problems in Interpreting Egyptian Art', in: *DE*, 17 (1990), 45-58.

Roth, *Absent Spouse*: A.M. Roth, 'The Absent Spouse: Patterns and Taboos in Egyptian Tomb Decoration', *JARCE*, 36 (1999), 37-53.

Idem, *JNES*: book review of N. Cherpion, *Mastabas et hypogées d'Ancien Empire. Le problème de la datation* (Bruxelles, 1989), *JNES*, 53 (1994), 55-58.

SAK: *Studien zur Altägyptischen Kultur* (Hamburg).

Schäfer, *Principles*: H. Schäfer (J. Baines, transl.), *Principles of Egyptian Art* (Oxford, 1975).

Scharff, *Grab als Wohnhaus*: A. Scharff, *Das Grab als Wohnhaus in der ägyptischen Frühzeit* (München, 1947).

Scheman, *Forms of Life*: N. Scheman, 'Forms of life: Mapping the Rough ground', in: H. Sluga, D.G. Stern (eds.), *Wittgenstein* (Cambridge, 1996), 383-410.

Schneider, Raven, *Egyptische Oudheid*: H.D. Schneider, M.J. Raven, *De Egyptische Oudheid* ('s Gravenhage, 1981).

Schoske, *Akten*: S. Schoske (ed.), *Akten des vierten Ägyptologenkongresses München 1985*, 2, (Hamburg, 1989).

Segal, *Archaeology*: E.M. Segal, 'Archaeology and Cognitive Science' in Renfrew, Zubrow, *Ancient Mind*, 22-28.

Idem, *Stil und Statistik*: S. Seidlmayer, 'Stil und Statistik. Die Datierung dekorierten Gräber des Alten Reiches – ein Problem der Methode' in: J. Müller, A. Zimmermann (eds.), *Archäologie*, 17-51.

Idem, *Ikonographie*: id, 'Die ikonographie des Todes' in: H.O. Willems (ed.), *Social Aspects*, 205-252.

Seidlmayer, *Acts*: S. Seidlmayer (ed.), *Acts of the Symposium Religion in Contexts: Imaginary Concepts and Social Reality in Pharaonic Egypt, Berlin 29-31 October 1998* [in press].

Sethe, *PT: K.* Sethe, *Die altägyptischen Pyramidentexte*, 1-2 (Leipzig, 1908-1910).

Shanks, Tilly, *Re-constructing Archaeology*: M. Shanks, C. Tilly, *Re-constructing Archaeology. Theory and Practice* (London, 1992).

Shennan, *Quantifying Archaeology*: S. Shennan, *Quantifying Archaeology* (Edinburgh, 1997).

Siebels, *Sandals*: R. Siebels, 'The Wearing of Sandals in Old Kingdom Tomb Decoration', *BACE*, 7 (1996), 75-88.

Sluga, Stern, *Wittgenstein*: H. Sluga, D.G. Stern (eds.), *The Cambridge Companion to Wittgenstein* (Cambridge, 1996).

Sørensen, *Introduction*: J. P. Sørensen, 'Introduction', in: Englund (ed.) *Religion*, 3-6.

Idem, *Access*: id., 'Divine Access: The So-called Democratization of Egyptian Funerary Literature as a Socio-cultural Process, in: Englund (ed.) *Religion*, 109-125.

Spigelman, *Circumcision*: 'Circumcision in Ancient Egypt', *BACE*, 7 (1996), 15-23.

Stern, *Wittgenstein*: D.G. Stern, *Wittgenstein on Mind and Language*, (New York, Oxford, 1995)

Strudwick, *Administration*: N. Strudwick, *The Administration of Egypt in the Old Kingdom* (London, 1985).

Vandersleyen, *Ägypten*: C. VanderSleyen (ed.), *Das alte Ägypten* (Berlin, 1975).

Idem, *L'Égypte*: id., *L'Égypte et la Vallée du Nil, Tome 2. De la fin de l'Ancien Empire à la fin du Nouvel Empire* (Paris, 1995).

Vandier, *Manuel*: J. Vandier, *Manuel d'Archéologie Égyptienne* (Paris, I (1952), IV-V (1964-1969)).

Vasiljević, *Gefolge*: V. Vasiljević, *Untersuchungen zum Gefolge des Grabherrn in den Gräbern des Alten Reiches* (Belgrad 1995).

Versnel, *Reflections*: H.S. Versnel, 'Some Reflections on the Relationship Magic-Religion', *Numen*, 38, fasc. 2 (1999), 177-197.

Vovelle, *Idéologie*: M. Vovelle, *Idéologie et Mentalités* (Paris, 1982) (Dutch edition, *Mentaliteitsgeschiedenis, essays over leef- en beeldwereld* (Nijmegen, 1985).

Walle v.d., *Neferirtenef*: B. van de Walle, *La chapelle funéraire de Neferirtenef* (Bruxelles, 1978).

Walsem, van, R., Mastaba Project: R. van Walsem, 'The Mastaba Project at Leiden University', in: S. Schoske (ed.), Akten, 143-154.

Idem, *Iconographic Programmes:* id., 'The Interpretation of Iconographic Programmes in Old Kingdom Elite Tombs of the Memphite Area. Methodological and Theoretical (Re)considerations', in: C. Eyre (ed.), *Proceedings*, 1205-1213.

Idem, *Chaos*: id., 'The Struggle against Chaos as a "Strange Attractor" in Ancient Egyptian Culture. A Descriptive Model for the "Chaotic" Development of Cultural Systems', in: J. van Dijk (ed.), *Essays*, 317-342.

Idem, *Cattle-fording Scene*: id., 'The Caption of a Cattle-fording Scene in a Tomb at Saqqara and its Implications for the Seh/Sinnbild Discussion on Egyptian Iconography', in: W. Clarysse et al. (eds.), *Egyptian Religion*, 1469-1485.

Idem, *Djedmonthuiufankh*: id., *The Coffin of Djedmonthuiufankh in the National Museum of Antiquities at Leiden*, I (Leiden, 1997).

Idem, *Individuality*: id., 'Diversification and Variation in Old Kingdom Funerary Iconography as the Expression of a Need for "Individuality"', in S. Seidlmayer (ed.), *Acts [in press]*.

WB: A. Erman, H. Grapow, *Wörterbuch der Aegyptischen Sprache* (Leipzig, Berlin, 1929-1971).

Webster's Dictionary: *Webster's Third New International Dictionary of the English Language*, I-III (Chicago, London etc, 1976).

Weeks, *Art:* K. Weeks, 'Art, Word and the Egyptian World View', in: K. Weeks (ed.), *Egyptology and the Social Sciences* (Cairo 1979), 59-81.

Idem, *Egyptology:* id., (ed.), *Egyptology and the Social Sciences* (Cairo 1979).

Westendorf, *Bemerkungen:* W. Westendorf, 'Bemerkungen zur "Kammer der Wiedergeburt" im Tutanchamungrab', *ZÄS* 94 (1967), 139-150.

Wild, *Ti:* H. Wild, *Le tombeau de Ti,* 2 (Le Caire, 1953).

Willems, *Social Aspects:* H.O. Willems (ed.), *Social Aspects of Funerary Culture in the Egyptian Old and Middle Kingdoms. Proceedings of the International Symposium Held at Leiden University 6-7 June 1996* (Leuven, 2001).

Wilson, *Funeral Services:* J.A. Wilson, 'Funeral Services of the Egyptian Old Kingdom', *JNES,* 3 (1944), 201-218.

Wilson, Keil, *Cognitive Sciences:* R.A. Wilson, F.C. Keil, *The MIT Encyclopedia of the Cognitive Sciences* (Cambridge (MA), 1999).

Wittgenstein, *Tractatus:* L. Wittgenstein, *Tractatus logico-philosophicus, Tagebücher 1914-1916, Philosophische Untersuchungen* (Frankfurt am Main, 1990).

Idem, *Philosophische Untersuchungen, Philosophical Investigations:* id. (translated by G.E.M. Anscombe), (Oxford, 1967).

Wolf, *Kunst:* W. Wolf, *Die Kunst Ägyptens, Gestalt und Geschichte* (Stuttgart, 1957).

Woodfield, *Essential Gombrich:* R. Woodfield (ed.), *The Essential Gombrich* (London, 1996).

ZÄS: Zeitschrift für Ägyptische Sprache und Altertumskunde (Berlin).

Zubrow, *Knowledge:* E.B.W. Zubrow, 'Knowledge Representation and Archaeology: a Cognitive Example Using GIS' in. C. Renfrew, E.B.W. Zubrow (eds.), *The Ancient Mind. Elements of Cognitive Archaeology* (Cambridge, 1995).

SOURCES OF ILLUSTRATIONS
(and page(s) where mentioned in the text).

The following persons are thanked for their permission to reproduce the subsequent list of illustrations: H. Altenmüller, Y. Harpur, P. Hopkins (KPI Londen) en H. Parkinson:

fig. 1, p. 18	after Harpur, Decoration, fig. against p. 1; p. 9, 11, 17
fig. 2, p. 35	after id., fig. 82; p. 9, 10, 25 (n. 14), 33, 36, 37, 39 (n. 41)
fig. 3, p. 36	after id., fig. 83; p. 9, 25 (n. 14), 33, 34, 36, 39 (n. 41), 75, 93, 96 (n. 127)
fig. 4, p. 37:	after Moussa, Altenmüller, Nianchchnum, fig. 10; p. 33, 36, 38, 69, 72
fig. 5, p. 54:	after Harpur, o.c., plan 82; p. 17, 53 (n. 55), 54, 97
fig. 6, p. 55:	after id., plan 94; p. 17, 54, 97
fig. 7, p. 56:	after id., plan 97; p. 17, 54, 97
fig. 8, p. 57:	after id., plan 137; p. 17, 54, 97
fig. 9, p. 59:	after id., fig. 174; p. 53 (n. 59), 58, 69, 72, 93
fig. 10, p. 60:	after id., fig. 100; p. 53 (n. 59), 58, 93, 94 (n. 115)
fig. 11, p. 60:	after id., fig. 70; p. 69, 72, 74, 77 (n. 44),
fig. 12, p. 75:	after Feucht, Fishing, fig. 4; p. 69, 73, 74, 76
fig. 13, p. 76:	after Mohr, Hetep-her-akhti, fig. 34; p. 69, 73, 74, 76, 77 (n. 44)
fig. 14, p. 82:	after Wild, Ti, pl. 114; p. 80
fig. 15, p. 82:	after Harpur, o.c., fig. 211; p. 81, 89
fig. 16A, p. 88:	after Wittgenstein, Tractatus, 5.5423; p. 87
fig. 16B, p. 88:	after id., Philosophische Untersuchungen, 2,xi (Anscombe, o.c., 194); p. 87
fig. 17, p. 88:	after Gombrich, Art and Illusion (Dutch edition 1967, fig. 200 (= more complete than English edition 1995)); p. 87

Schema A, p. 44: p. 45, 52, 53, 54
Schema B, p. 52: p. 45, 51, 54
Schema C, p. 64: p. 63, 65

INDEX

PRINTED ON PERMANENT PAPER • IMPRIME SUR PAPIER PERMANENT • GEDRUKT OP DUURZAAM PAPIER - ISO 9706

N.V. PEETERS S.A., WAROTSTRAAT 50, B-3020 HERENT